Cambridge Ontario Part 3: Hespeler and Blair Village in Photos, Saving Our History One Photo at a Time

Photography
by Barbara Raué
2013

Series Name:
Cruising Ontario

Book 41: Hespeler

Cover photo: 11 Tannery Street East, former Hespeler City Hall

Series Name: Cruising Ontario

Book 1: London
Book 2: Dundas
Book 3: Hamilton
Book 4: Oakville
Book 5: Chesley
Book 6: Stoney Creek
Book 7: Waterdown
Book 8: Owen Sound
Book 9: Mount Forest
Book 10: Dundalk
Book 11: Burford
Book 12: Waterford
Book 13: Drumbo
Book 14: Sheffield
Book 15: Tavistock
Book 16: Ancaster and Mount Hope
Book 17: Innerkip
Book 18: Brantford
Book 19: Burlington
Book 20: Guelph
Book 21: Ayr
Book 22: Erin
Book 23: Goderich
Book 24: Lucknow
Book 25: Paris
Book 26: Toronto
Book 27: Beaver Valley
Book 28: Collingwood
Book 29: Peterborough
Book 30: Orangeville Beginnings Part 1
Book 31: Orangeville Part 2 and Area
Book 32: Port Elgin
Book 33: Southampton
Book 34: Jarvis
Book 35: Hagersville
Book 36: Caledonia
Book 37: Simcoe
Book 38: Galt Book 1
Book 39: Galt Book 2
Book 40: Preston
Book 41: Hespeler
Book 42: Kitchener
Book 43: Waterloo
Book 44: Shelburne
Book 45: Alton

Other Books by Barbara Raue

Coins of Gold

Arrows, Indians and Love

The Life and Times of Barbara
Volume 1: Inventions That Have Enhanced My Life
Volume 2: Entertainment That I Have Enjoyed
Volume 3: East Coast Trips
Volume 4: Olympics Have Always Intrigued Me
Volume 5: Wonders of the World
Volume 6: Caribbean Cruises We Have Enjoyed
Volume 7: Animals
Volume 8: Storms and Other Major Disasters in My Lifetime
Volume 9: Wars, Terrorist Attacks and Major Disasters

The Cromwell Family Book

Visit Barbara's website to view all of her books
http://barbararaue.ericraue.com

Blair Village

The Bowman and Bechtel families are credited with starting the development of the village of Blair. Joseph Bowman built the first dam in the village, located on Bowman Creek, and erected the area's first sawmill, the first industrial enterprise in the village. Henry Bechtel built the Durham Flour Mill in the early 1830s. Blair Village became part of Preston in 1969 and became part of Cambridge in 1973.

Hespeler

This area was originally part of the land granted to the Six Nations Indians by the British Crown in 1784. The Indians led by Joseph Brant sold part of their block of land measuring 90,000 acres to Richard Beasley and his partners. A group of Pennsylvania Mennonites agreed to buy some of the land and began arriving in the Hespeler area in 1809. The most important of the area's early settlers was Jacob Hespeler, the man who gave the settlement its permanent name. Jacob Hespeler was born in Germany, educated in France and emigrated to Canada with eight of his brothers and sisters. In about 1835 he moved to the German community of Preston where he opened a store. He looked for land in order to build a grist mill and found a suitable site on the Speed River in the settlement of New Hope. He also built a sawmill, a cooperage, a gas house, a distillery and a stone woollen mill. The name of the village was changed to Hespeler in 1859 with the arrival of the Great Western Railway.

Blair Village

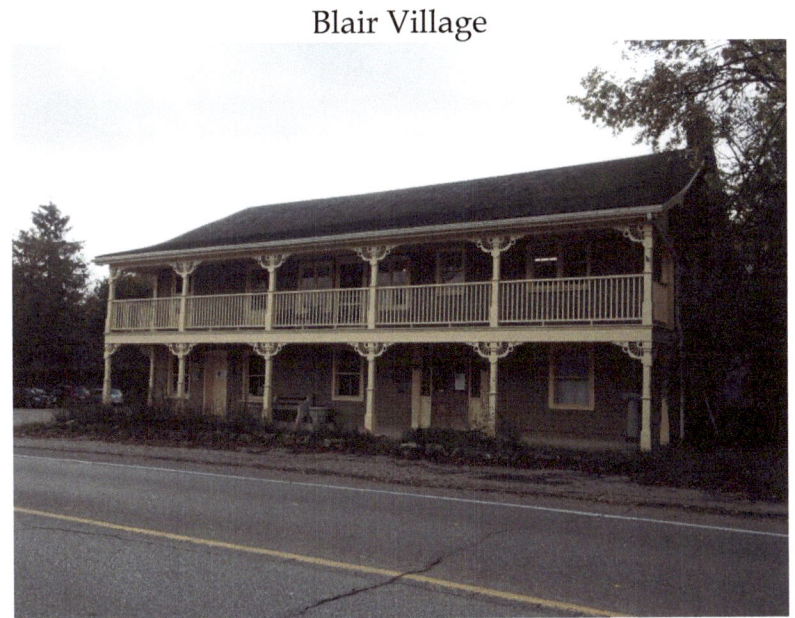

1679 Blair Road – John Lamb, Innkeeper, Lamb's Inn c. 1837
Georgian style

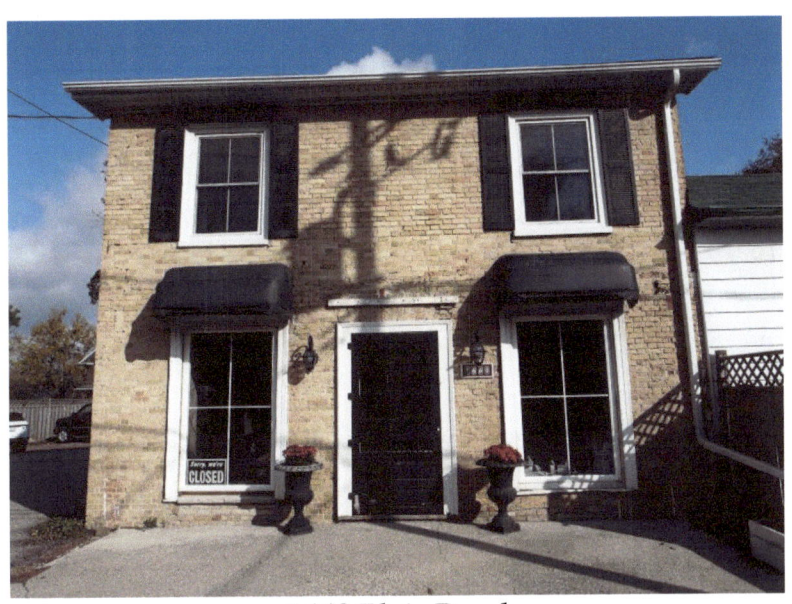

1660 Blair Road

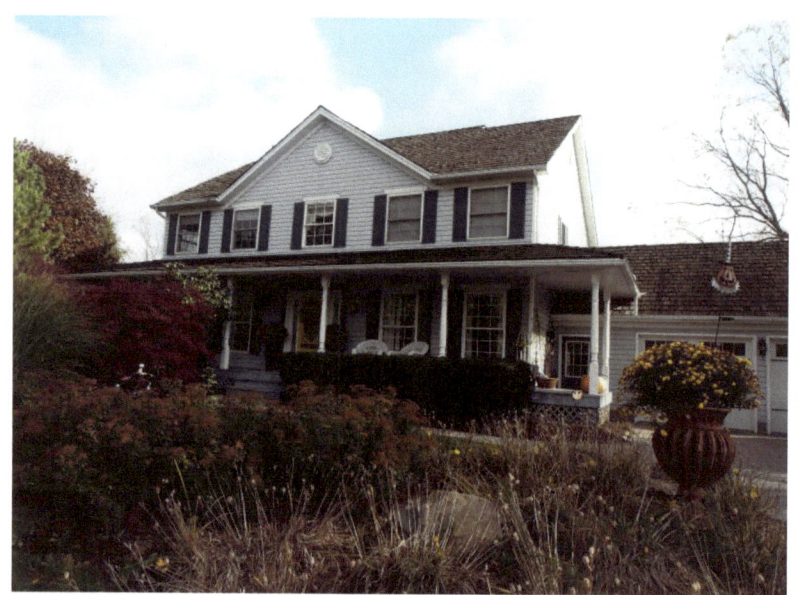

12 Ashton Street, next to the cemetery – Georgian style

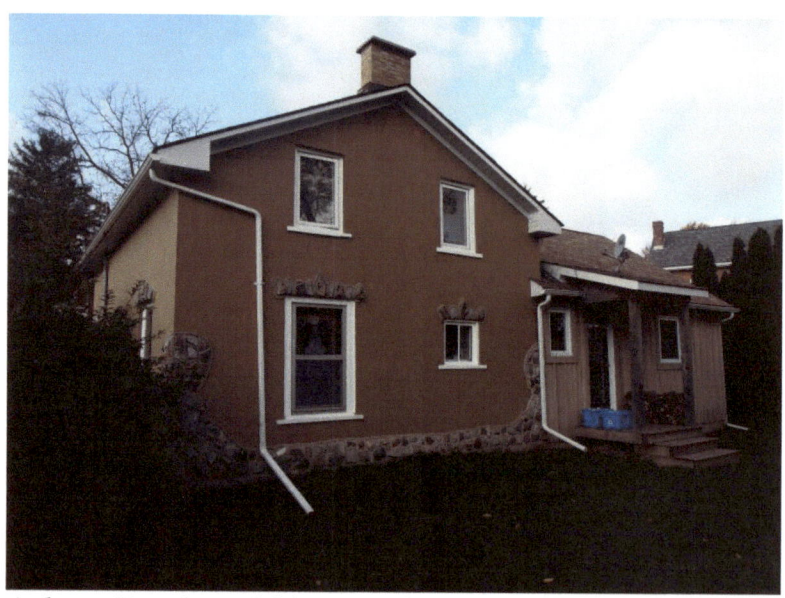

Ashton Road – cobblestone basement – Gothic Revival

1680 Blair Road – Gothic Revival, yellow brick

1705 Blair Road – Edwardian style

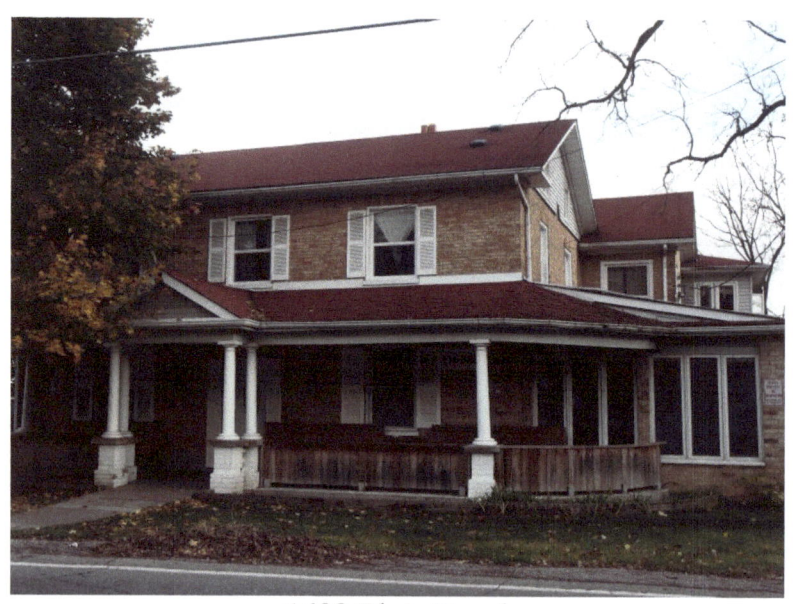

1688 Blair Road

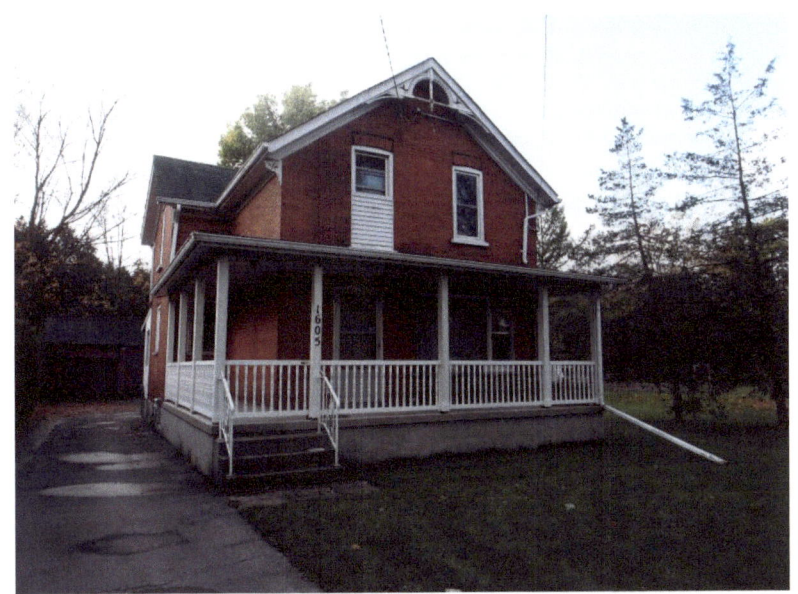

1605 Blair Road – Gothic Revival – Vergeboard trim

1½ storey Gothic Revival

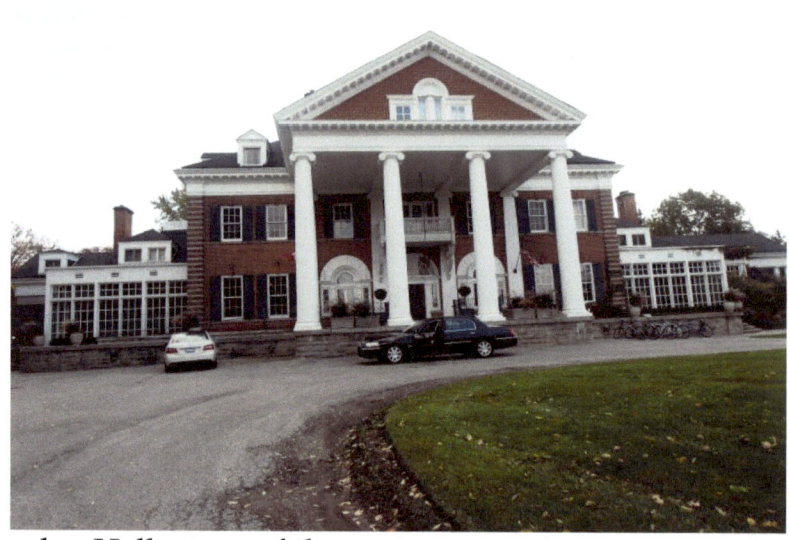

Langdon Hall – turn of the century mansion – now an elegant country inn

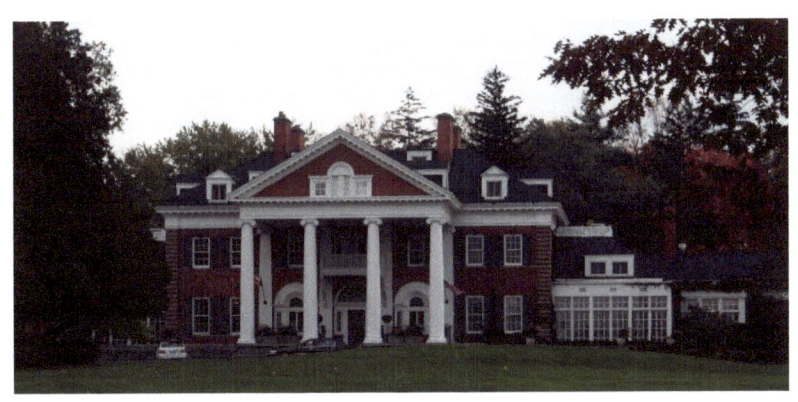

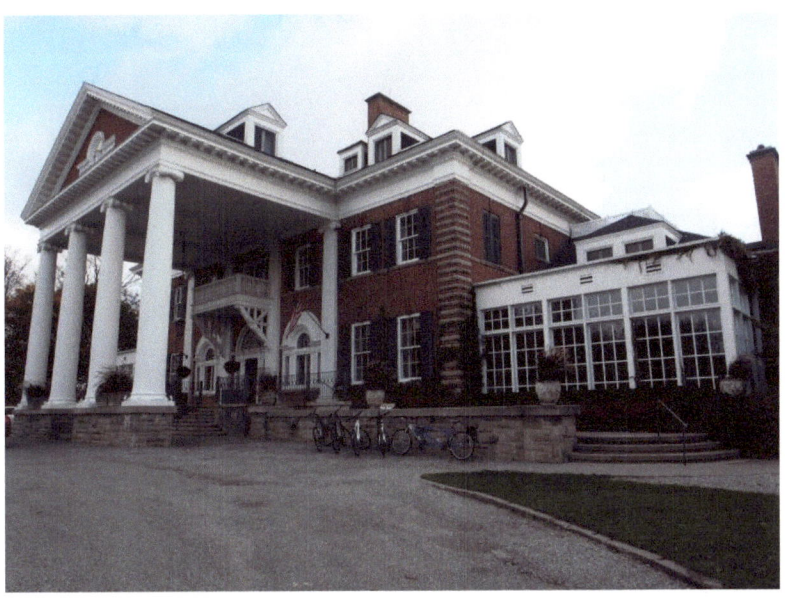

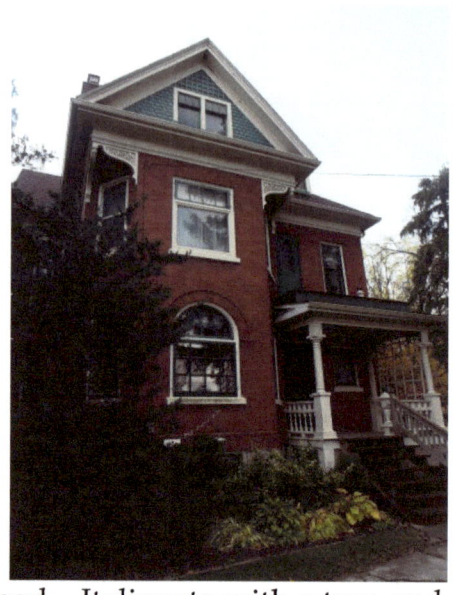

1585 Blair Road – Italianate with a two-and-a-half storey tower-like bay with projecting eaves and large fretwork pieces resembling brackets, dormer in the attic

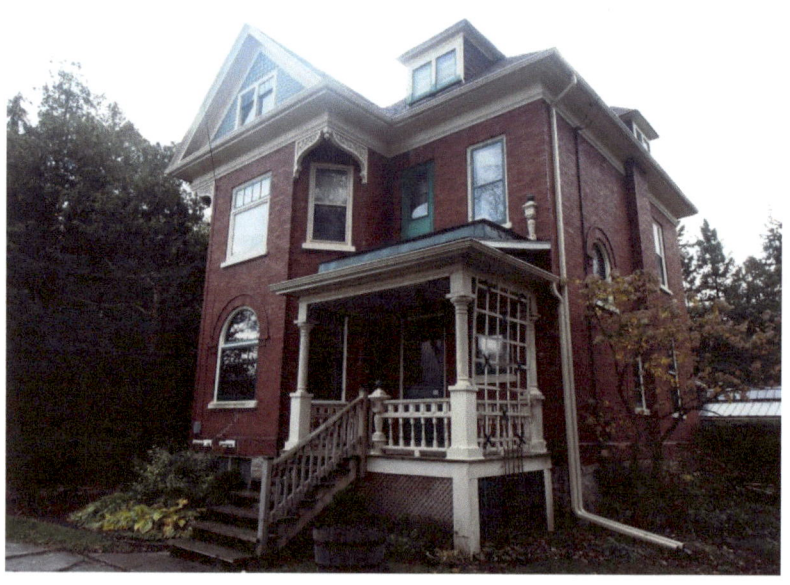

Fallbrook Lane – Samuel Bechtel farm

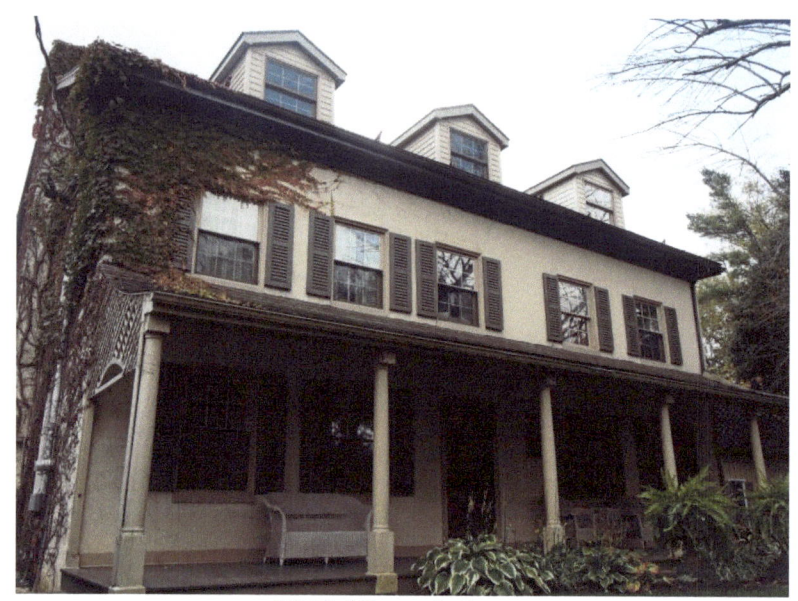
58 Fallbrook Lane

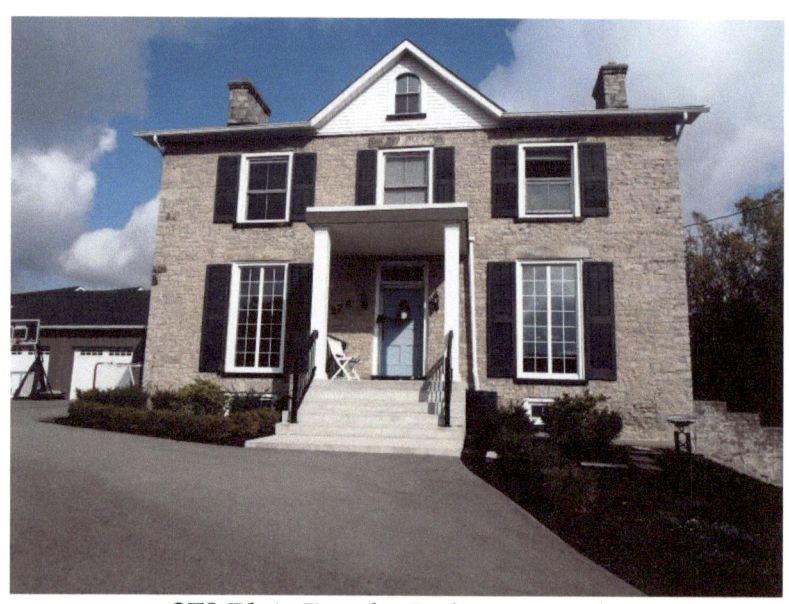
278 Blair Road – Italianate style

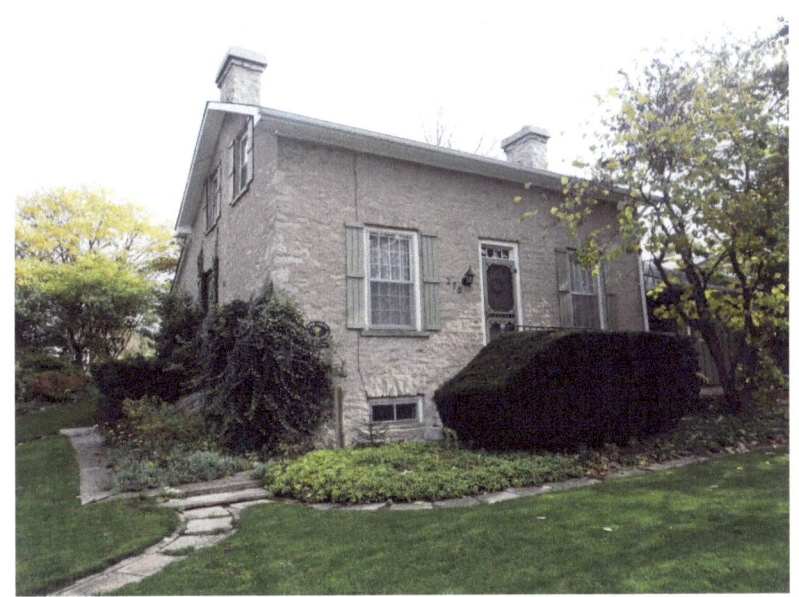

276 Blair Road – stone building

245 Blair Road – Italianate style with dormer in attic

146 Blair Road – Georgian style

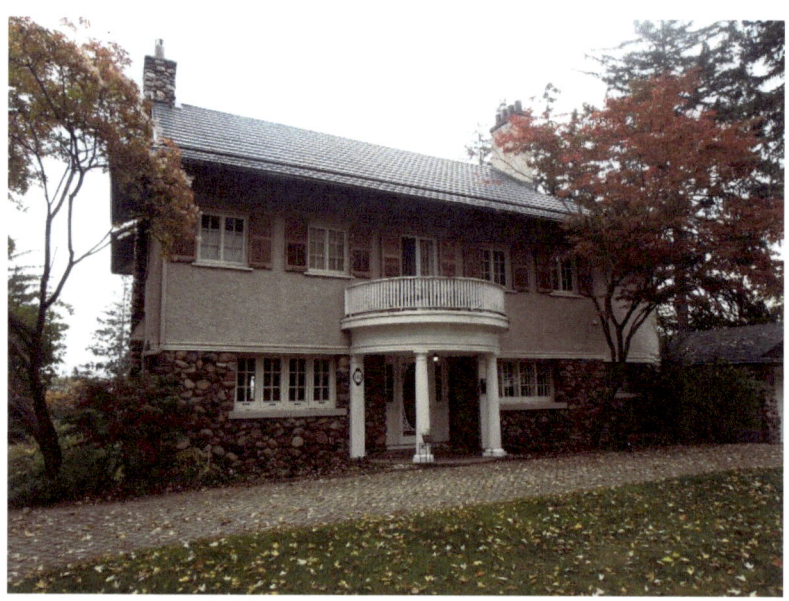

142 Blair Road – Georgian style

Blair Road – Regency Cottage

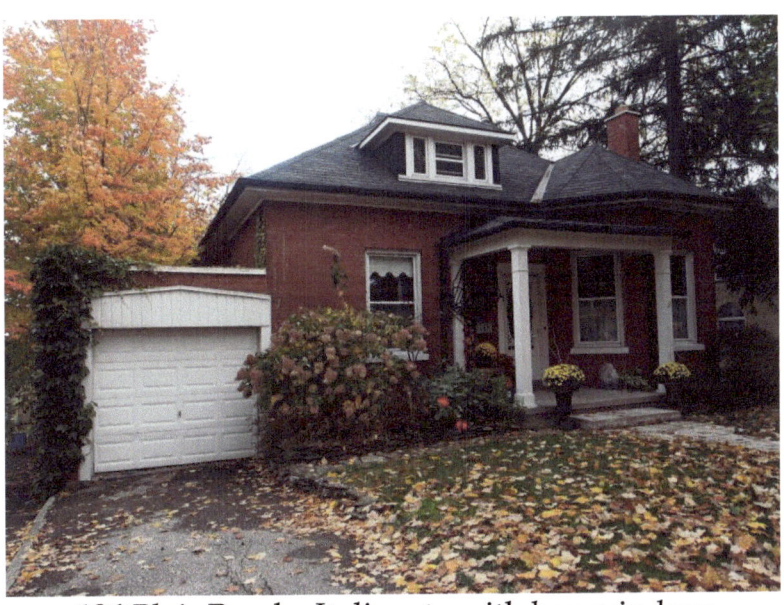

136 Blair Road – Italianate with bay window

Blair Road – Italianate style

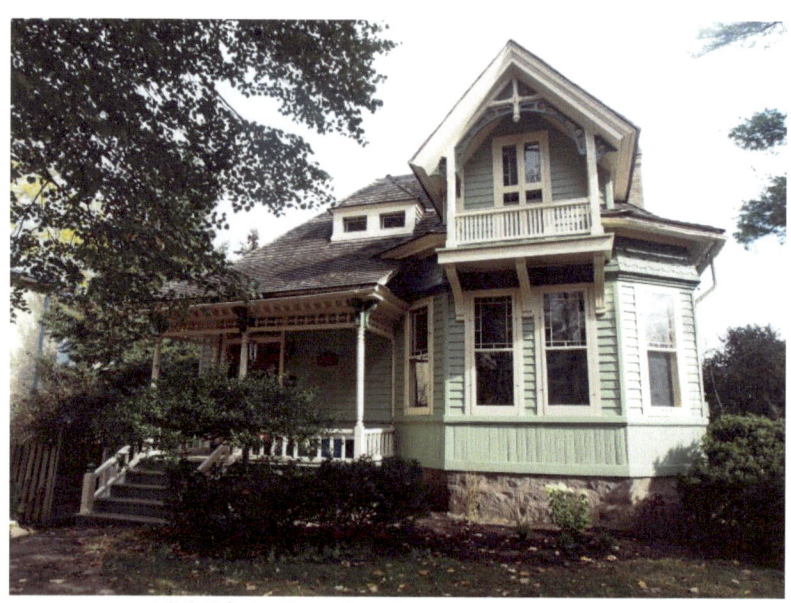

126 Blair Road – Queen Anne style

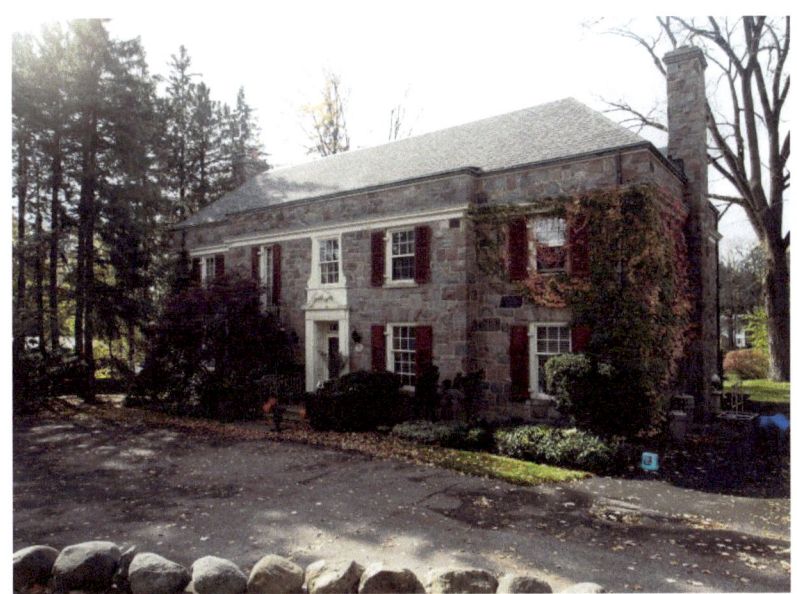

119 Blair Road – cobblestone – Georgian style

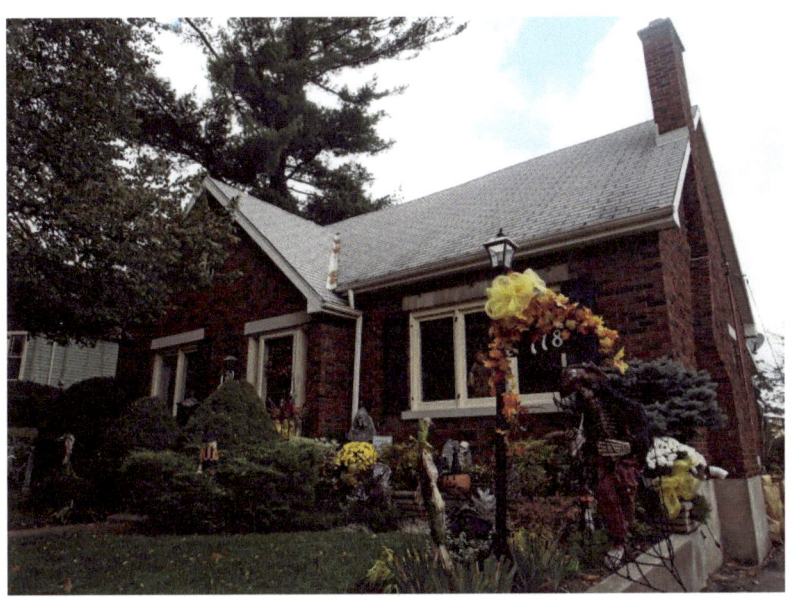

118 Blair Road – red brick – Gothic Revival

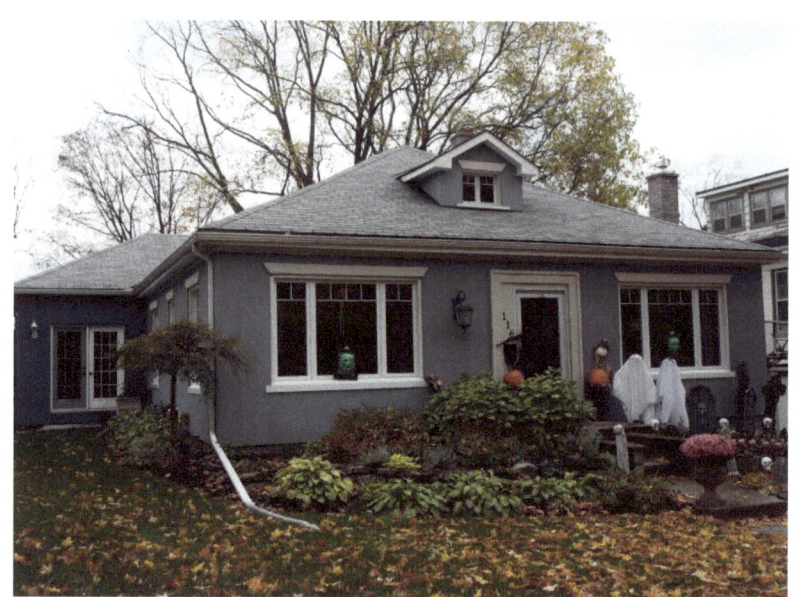

116 Blair Road – Regency Cottage, dormer in attic

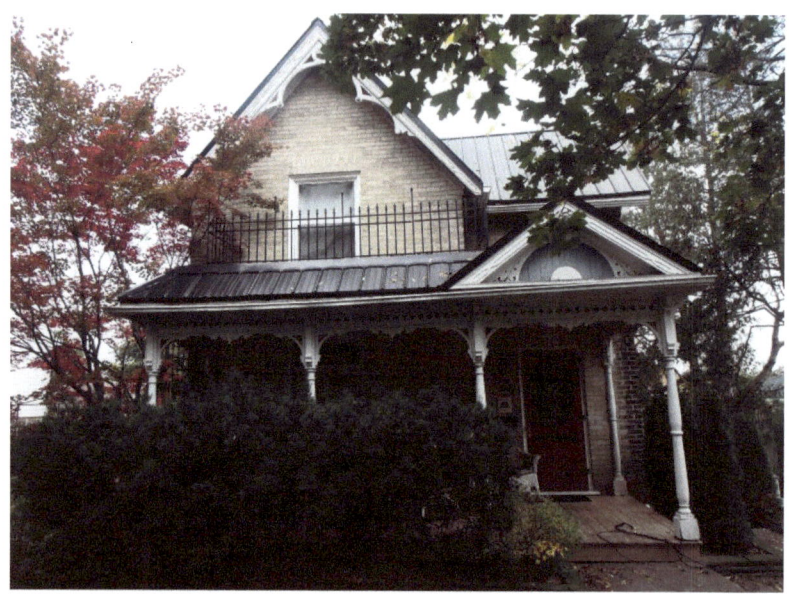

104 Blair Road – Gothic Revival – Vergeboard trim

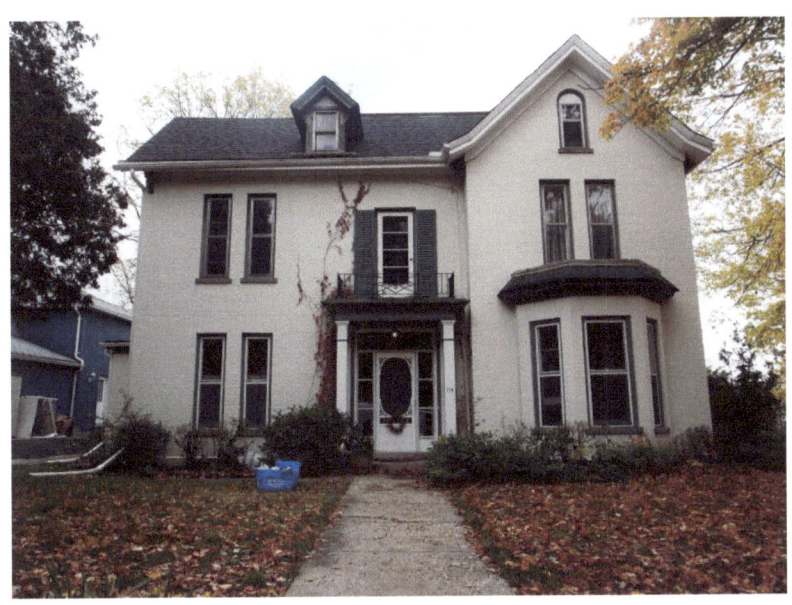

114 Blair Road – Italianate style with two-and-a-half storey tower-like bay, dormer in attic

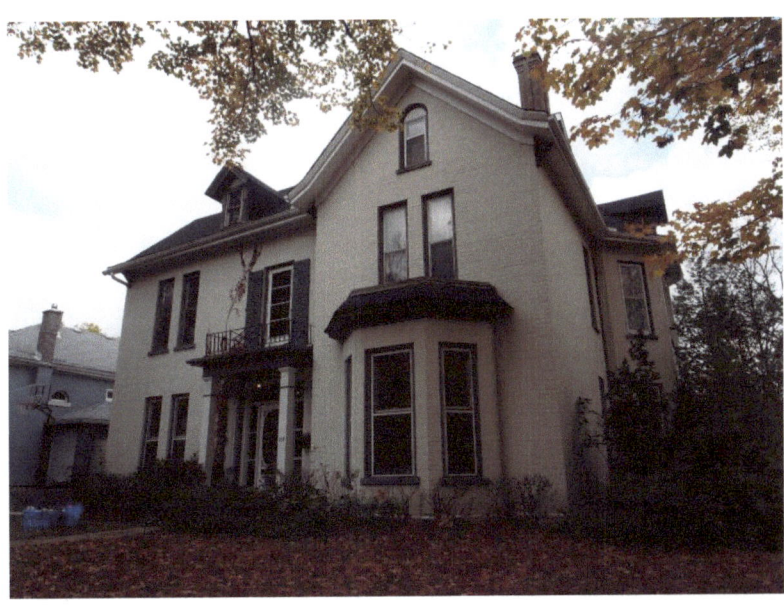

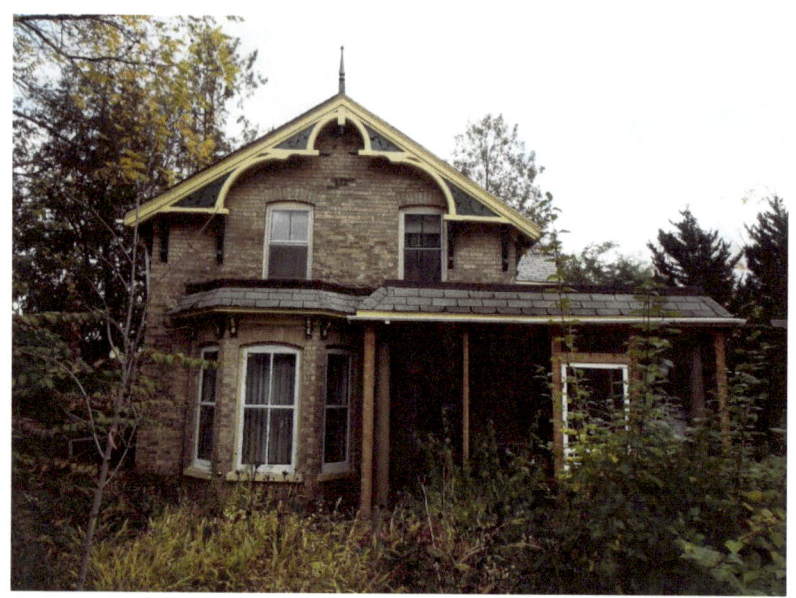

Blair Road – Gothic Revival – Vergeboard trim, bay window on ground floor with cornice brackets

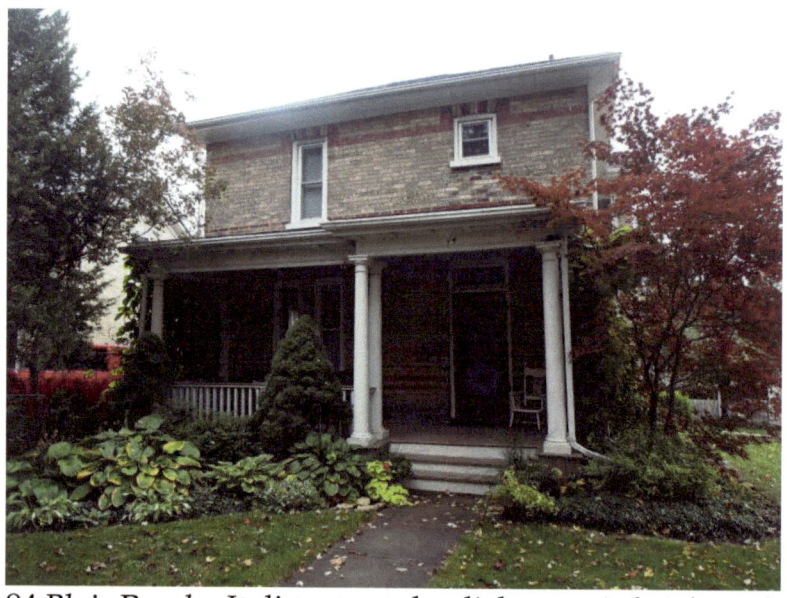

94 Blair Road – Italianate style, dichromatic brickwork

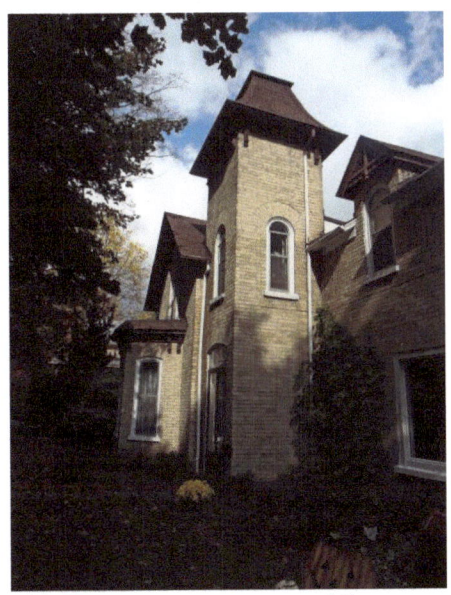

96 Blair Road - Two-storey tower-like structure with a uniquely shaped capped roof

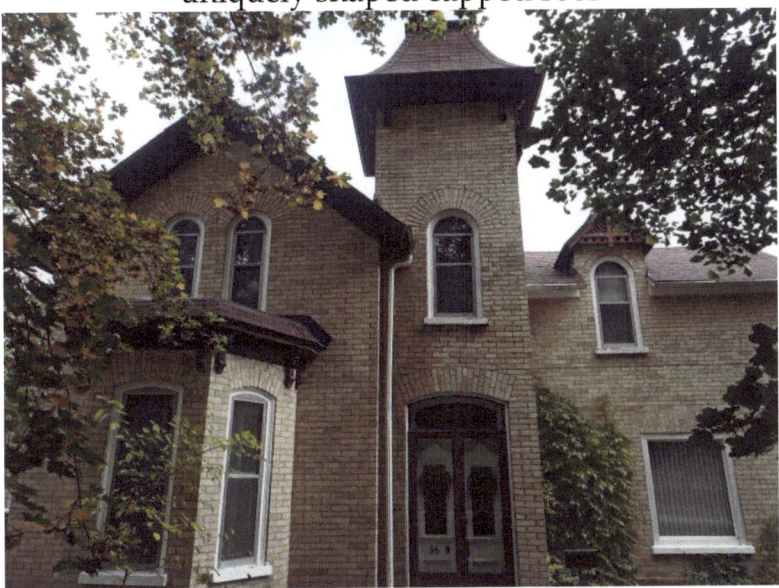

Arched window voussoirs, Vergeboard trim on gable in attic

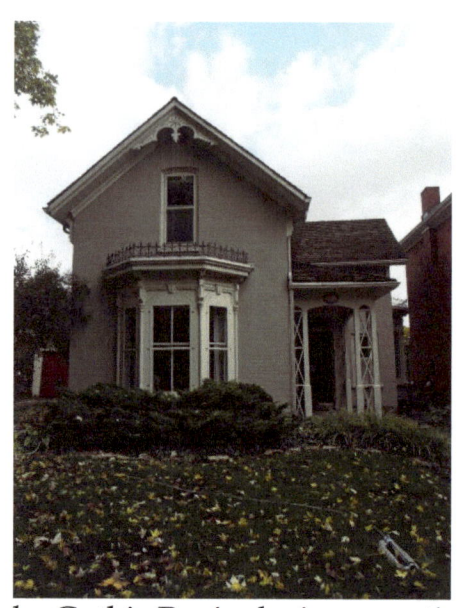

90 Blair Road – Gothic Revival – iron cresting above bay window, Vergeboard trim on gable

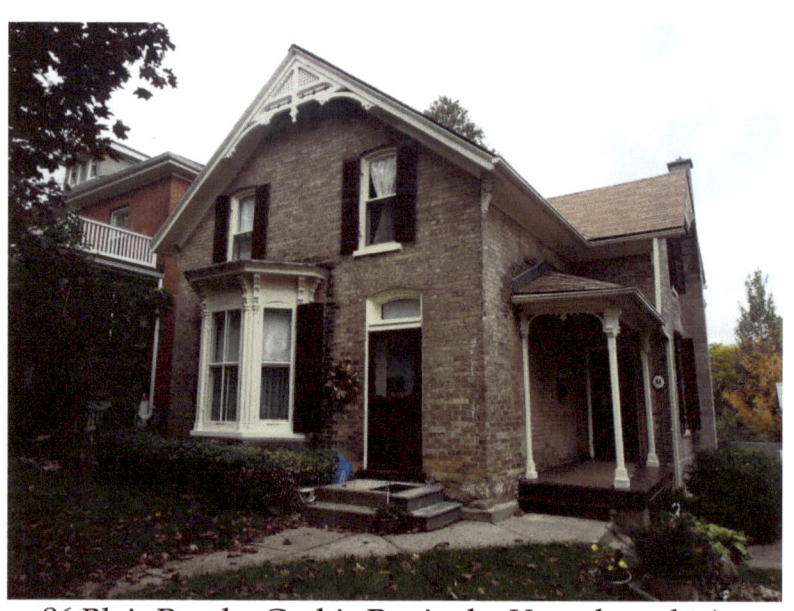

86 Blair Road – Gothic Revival – Vergeboard trim

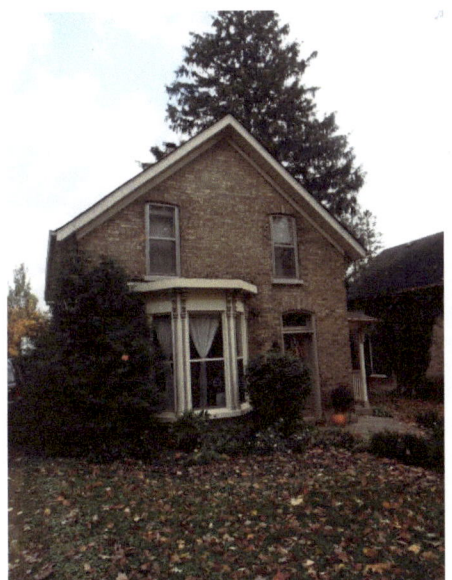 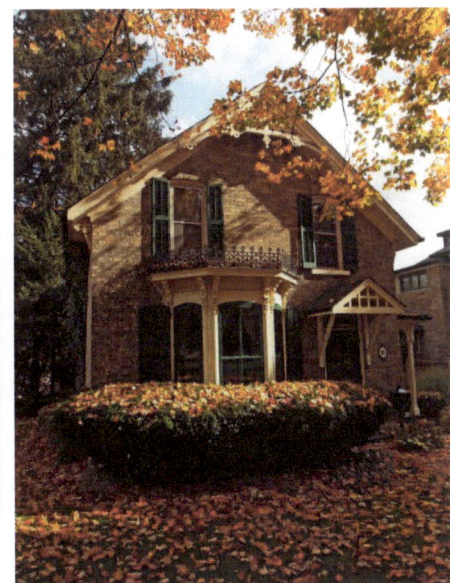

82 Blair Road – Gothic Revival 84 Blair Road – Gothic Revival
Iron crestwork above bay
window, Vergeboard trim on gable

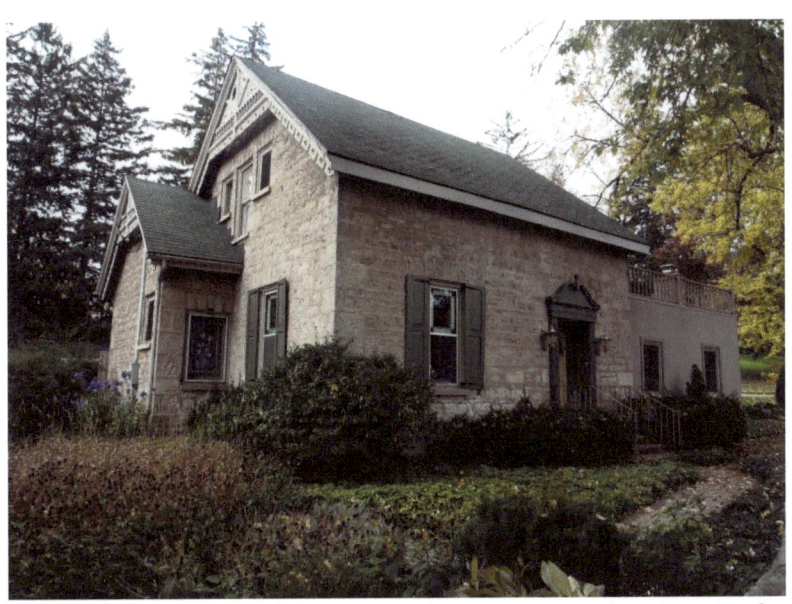

Blair Road – cobblestone – 1½ storey Gothic Revival,
Vergeboard trim on gables

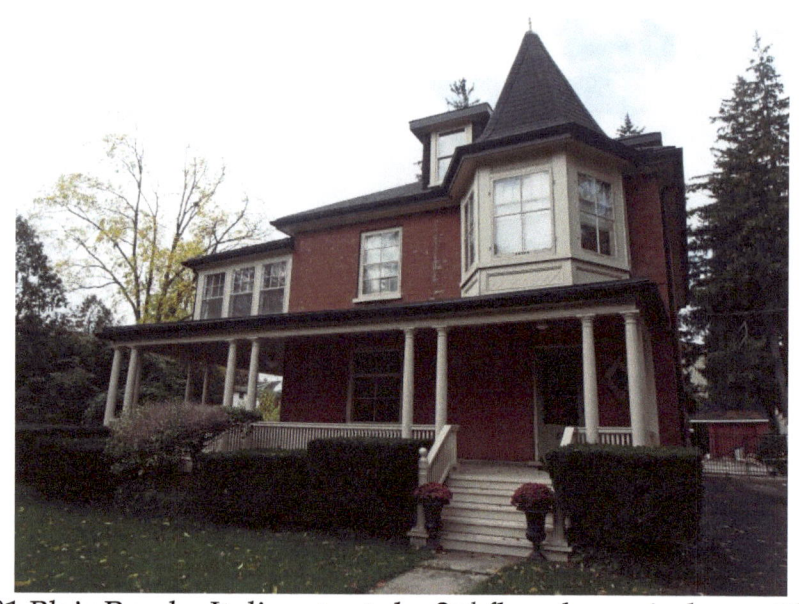

81 Blair Road – Italianate style, 2nd floor bay window with cone shaped cap, dormer in attic

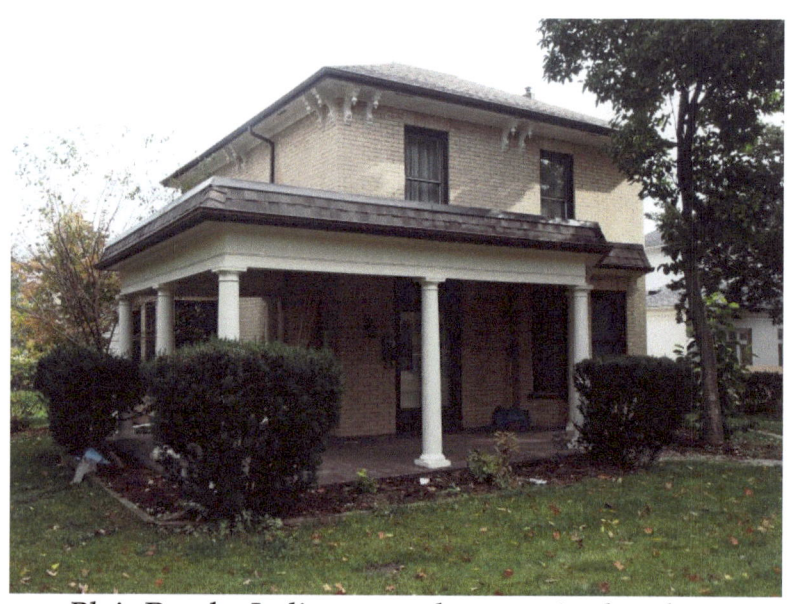

Blair Road – Italianate style – cornice brackets

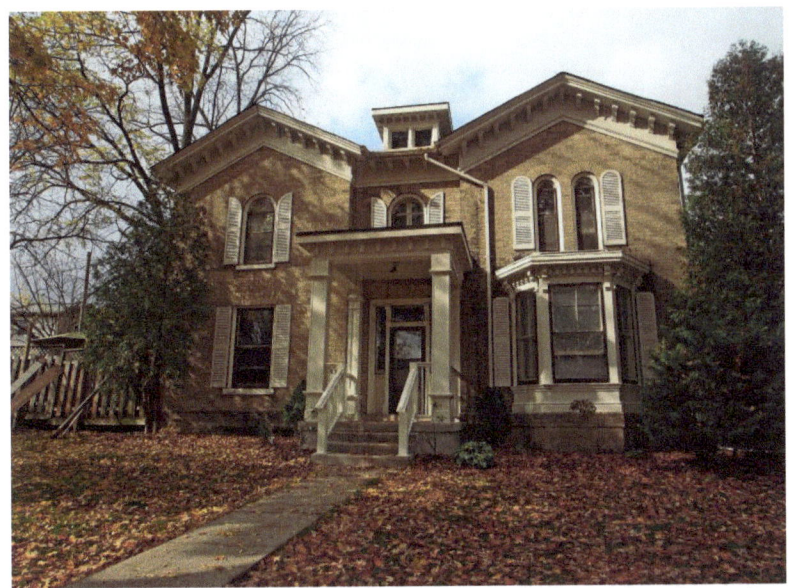

Blair Road – Gothic Revival – belvedere on rooftop, bay window on ground floor with cornice brackets, arched window voussoirs, cornice brackets on gables

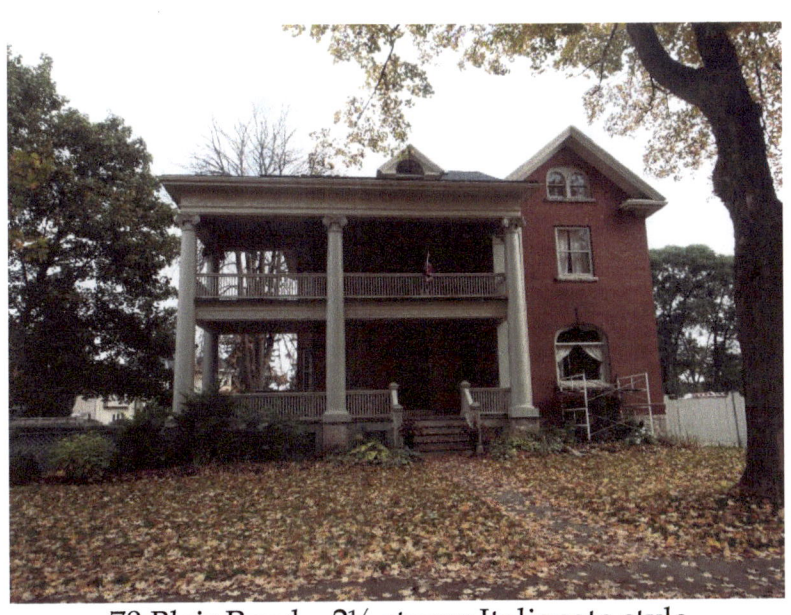

70 Blair Road – 2½ storey Italianate style

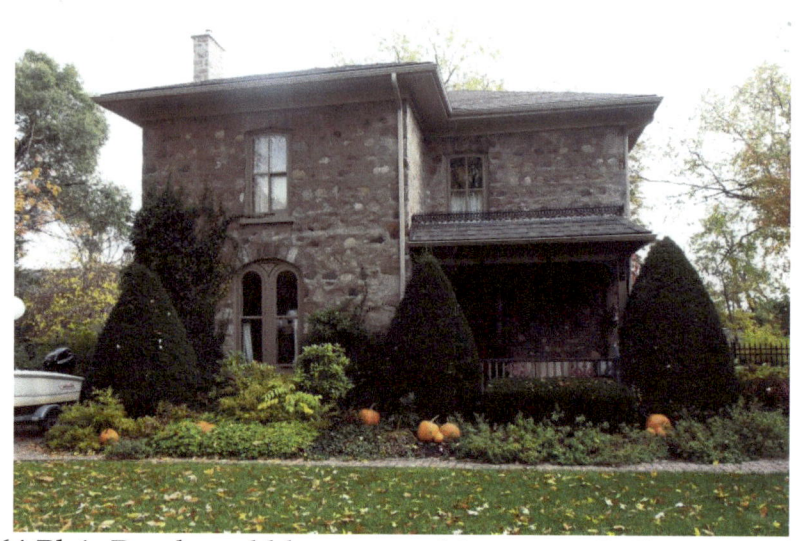
64 Blair Road – cobblestone architecture – Italianate style

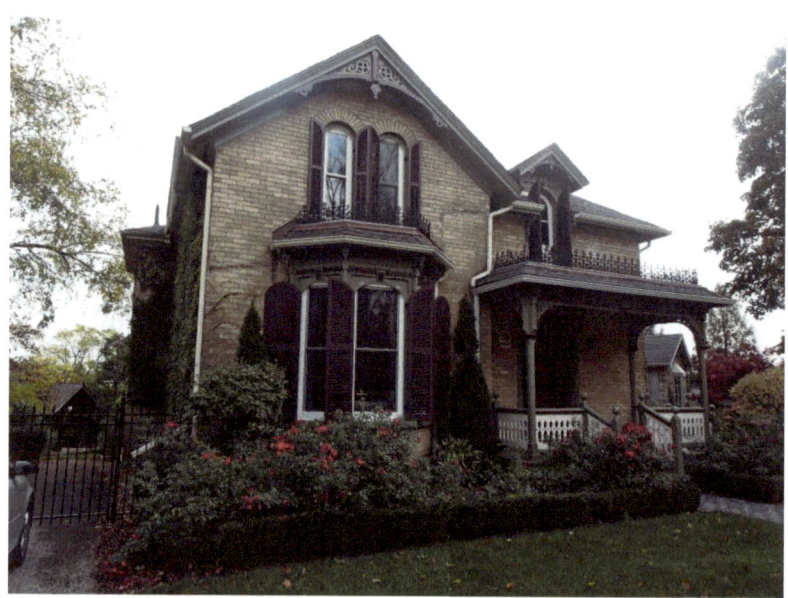
58 Blair Road – Gothic Revival, iron cresting above bay window and above verandah, Vergeboard trim on gables

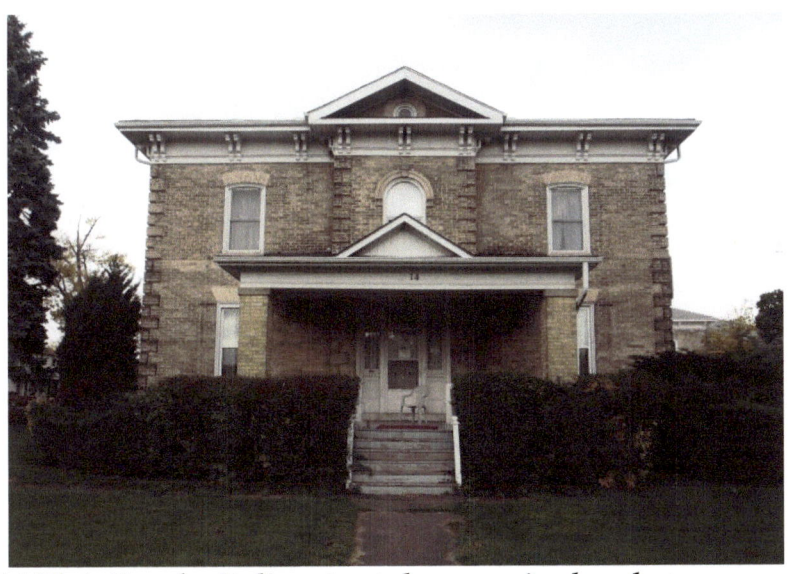

14 Blair Road – Italianate style – cornice brackets, corner quoins, frontispiece with triangular pediment above door and above roof with decorative tympanum

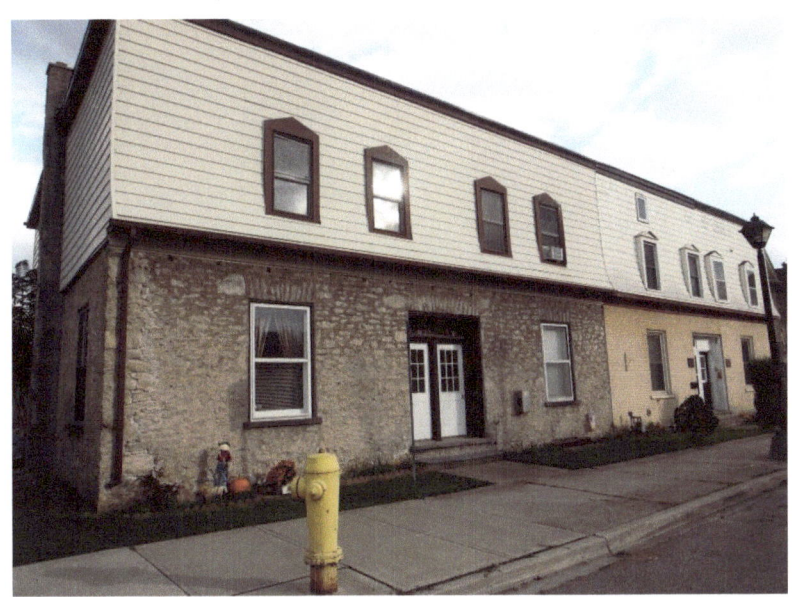

Blair Road

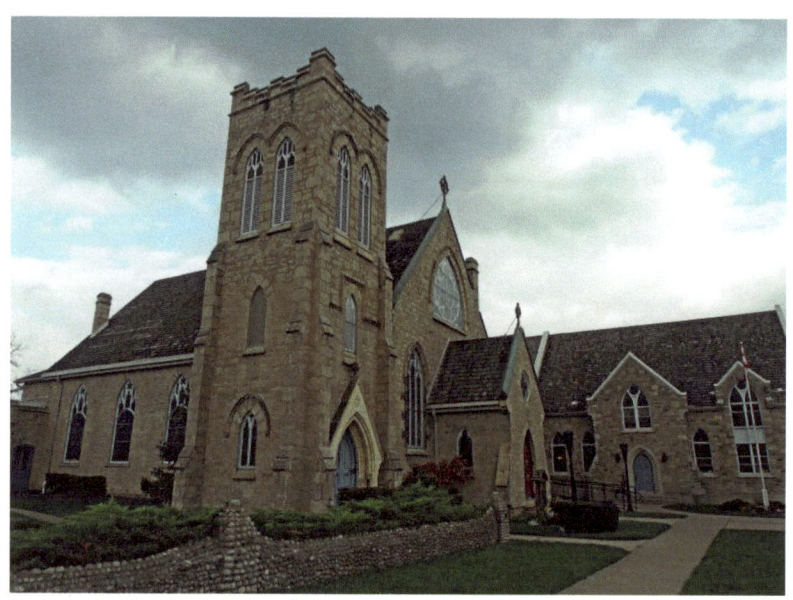

12 Blair Road – Trinity Anglican Church

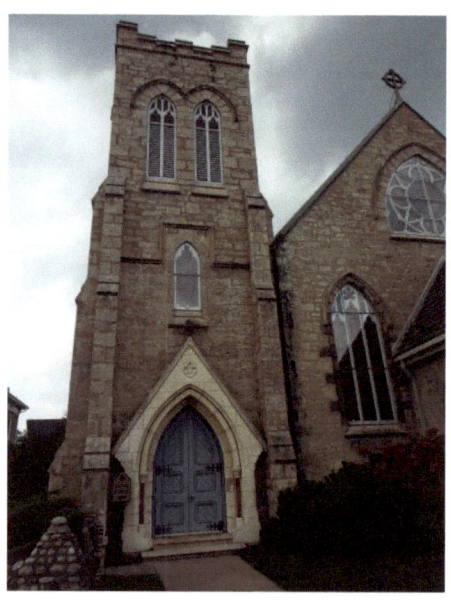

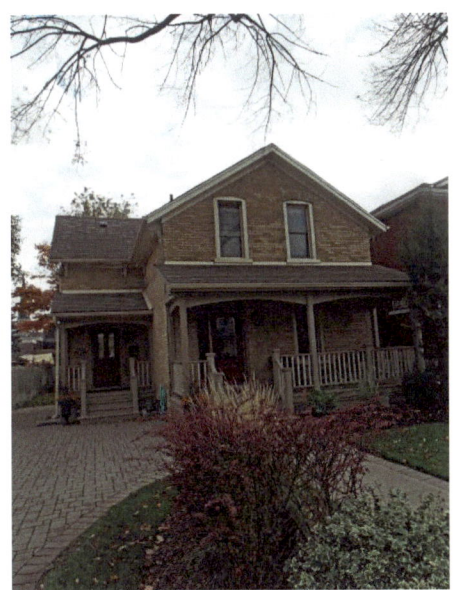

29 Blair Road

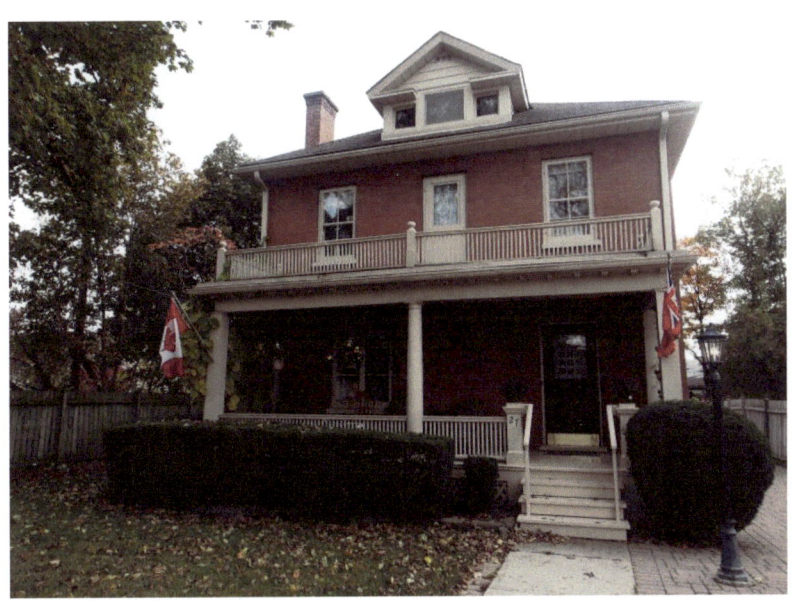

27 Blair Road – Italianate style, dormer in attic

Hespeler

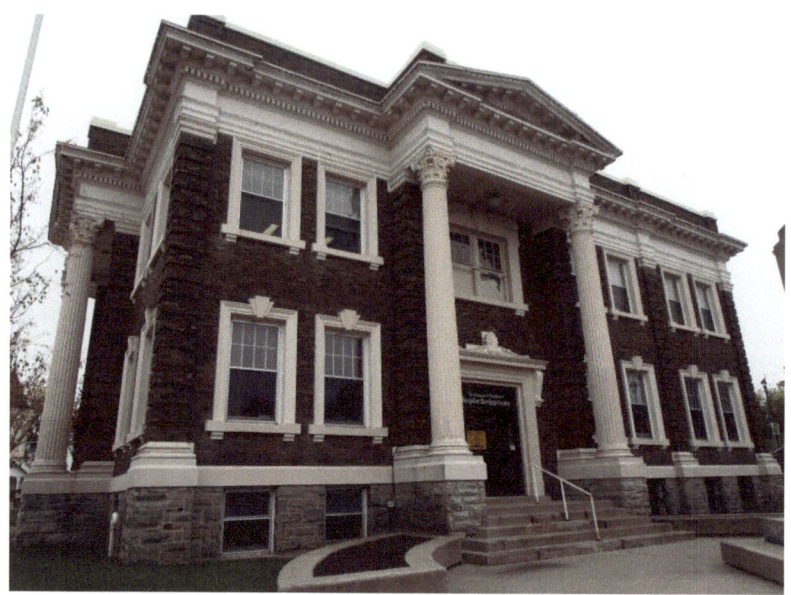

11 Tannery Street East – former City Hall – c. 1914
Beaux Arts style

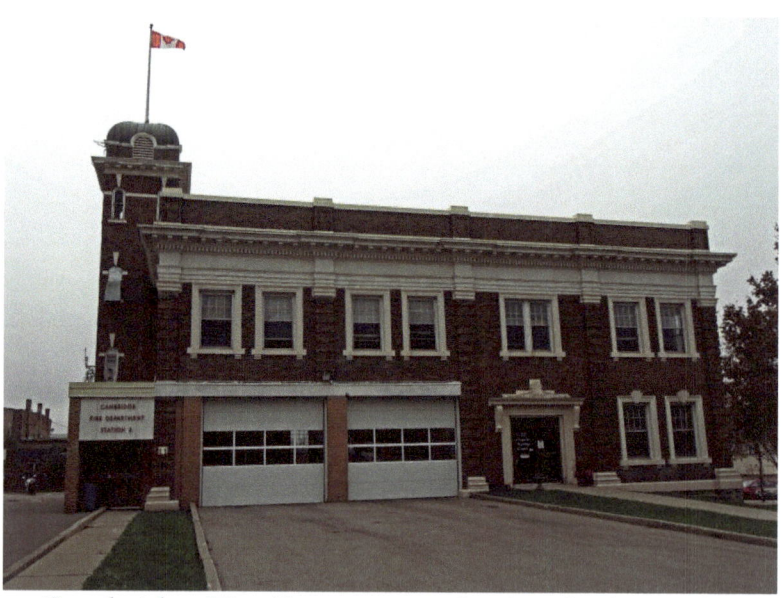

Cambridge Fire Department Station 2 – Hespeler

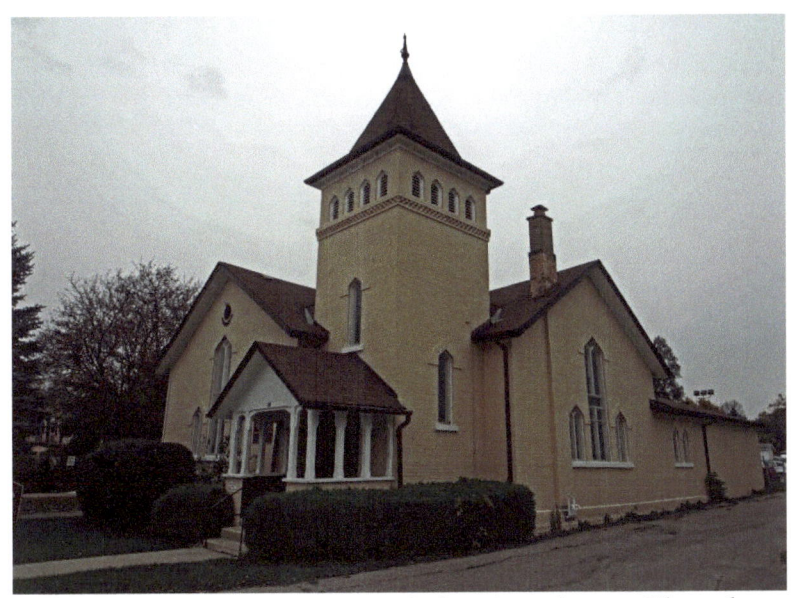

18 Tannery Street East – Salvation Army Church

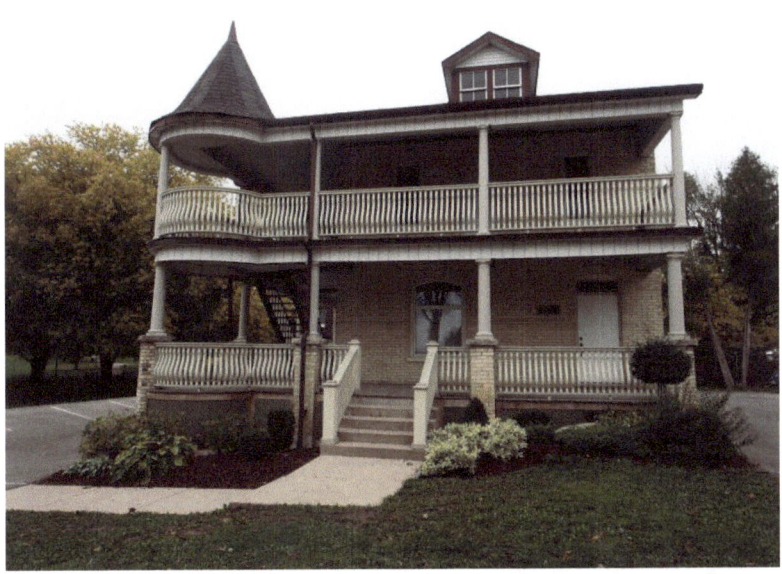

22 Tannery Street East – wrap-around balconies on first and second storeys, belvedere on rooftop, cone-shaped cap on corner – yellow brick

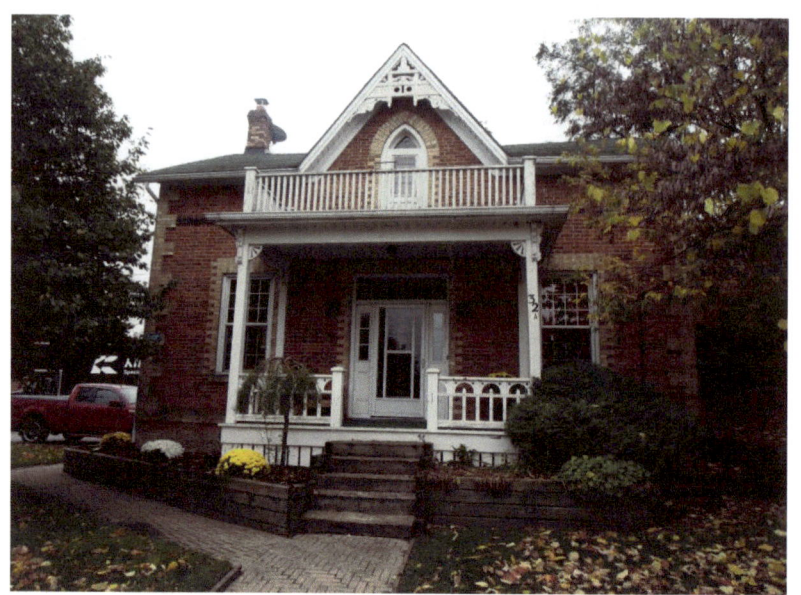

32 Adam Street – 1½ storey Gothic Revival, corner quoins, Vergeboard trim on gable, arched window voussoir

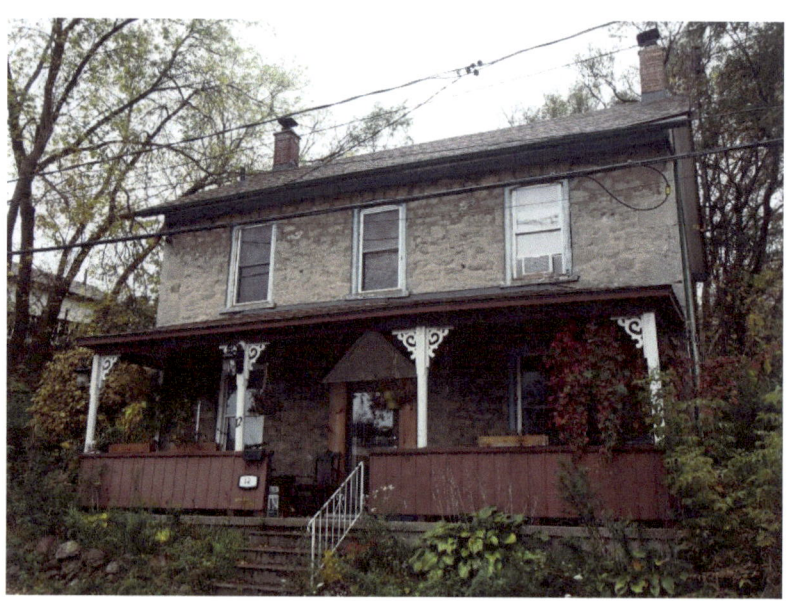

12 Adam Street – Georgian style

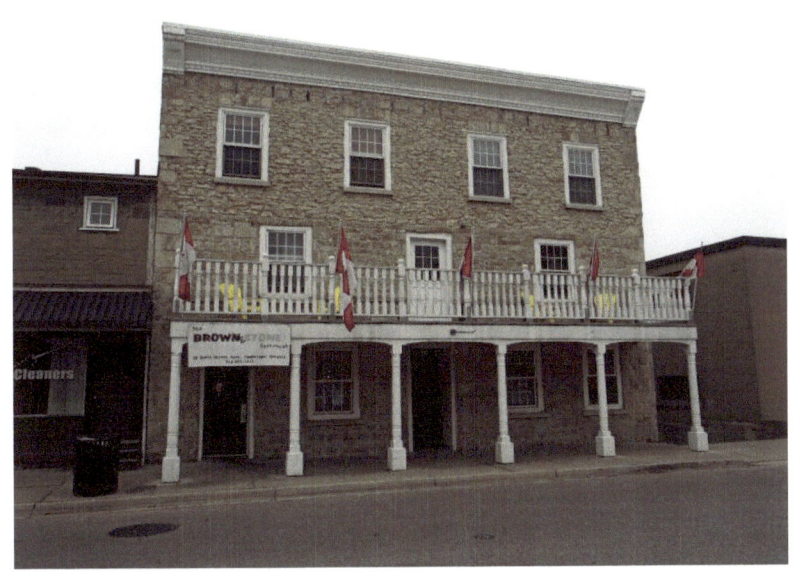

39 Queen Street East

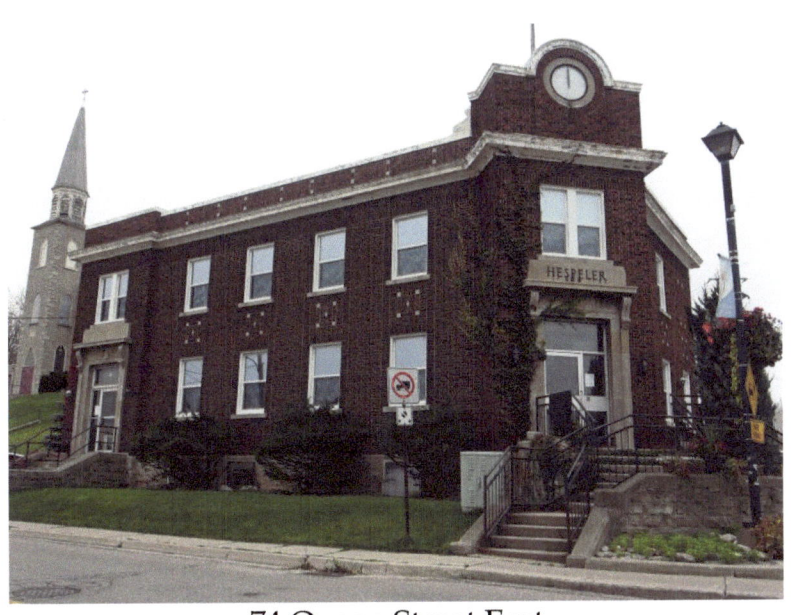

74 Queen Street East

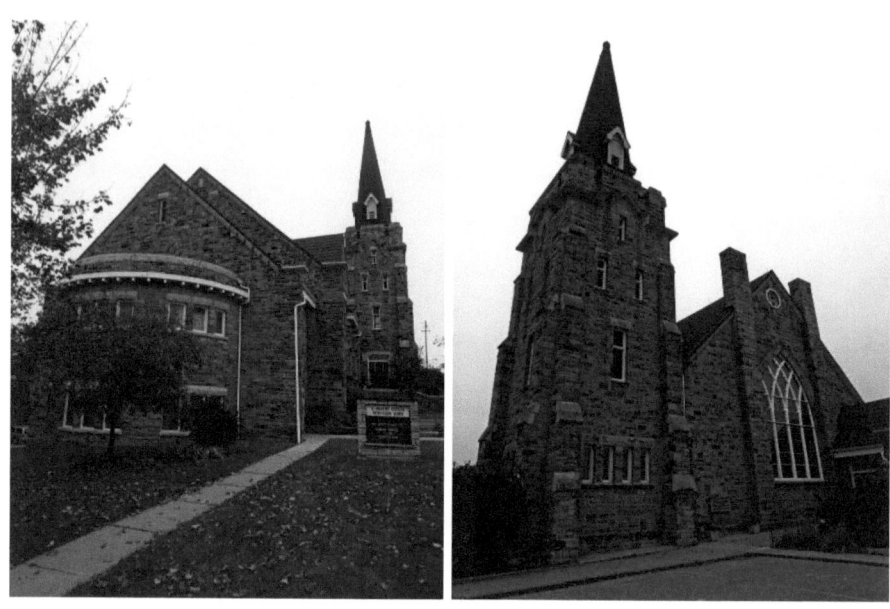

73 Queen Street East, St. Andrews Presbyterian Church - 1908

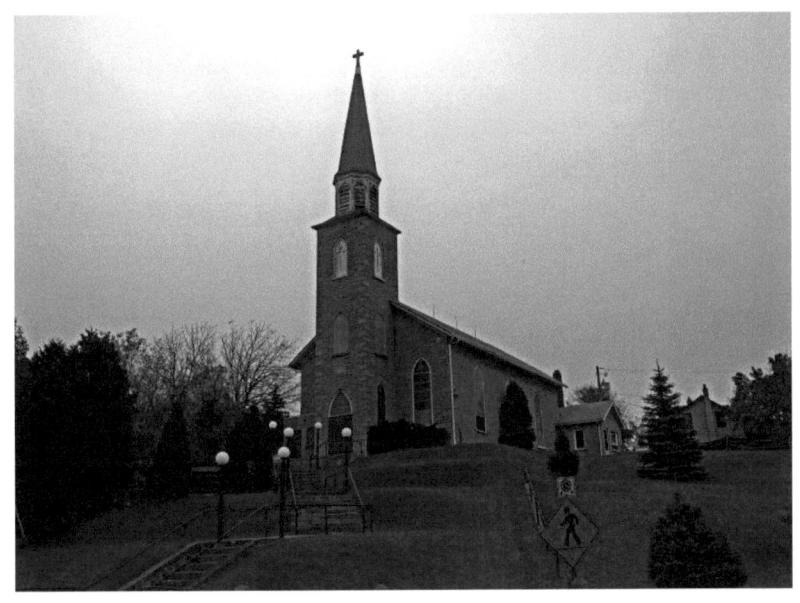

96 Queen Street East – St. James Lutheran Church

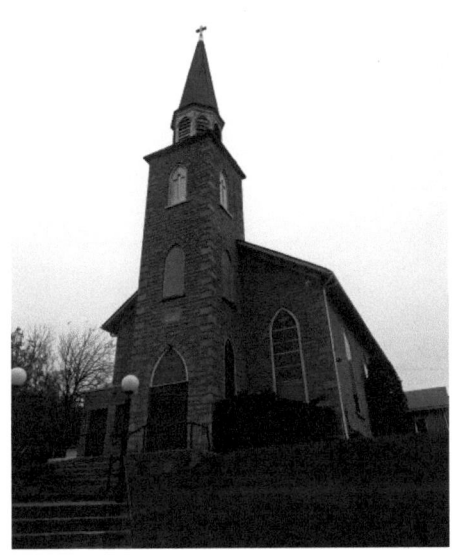

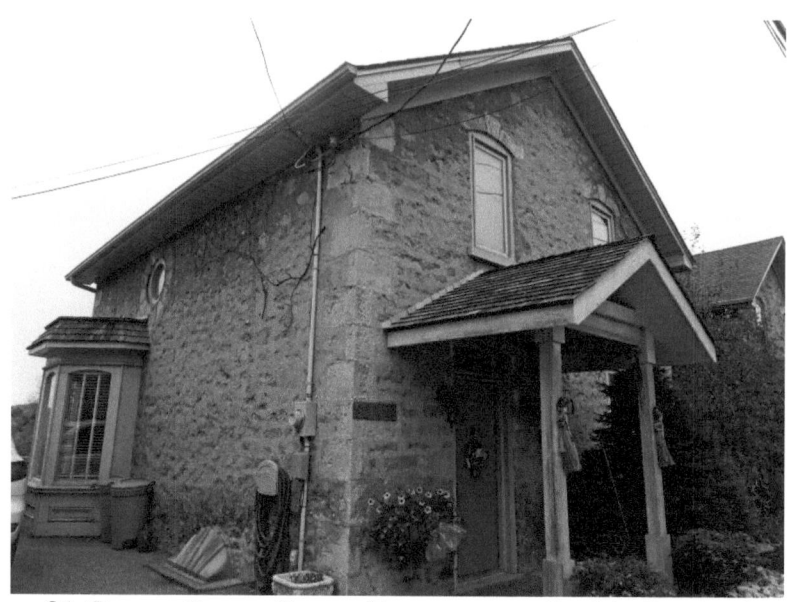

91 Queen Street East – limestone – Gothic Revival

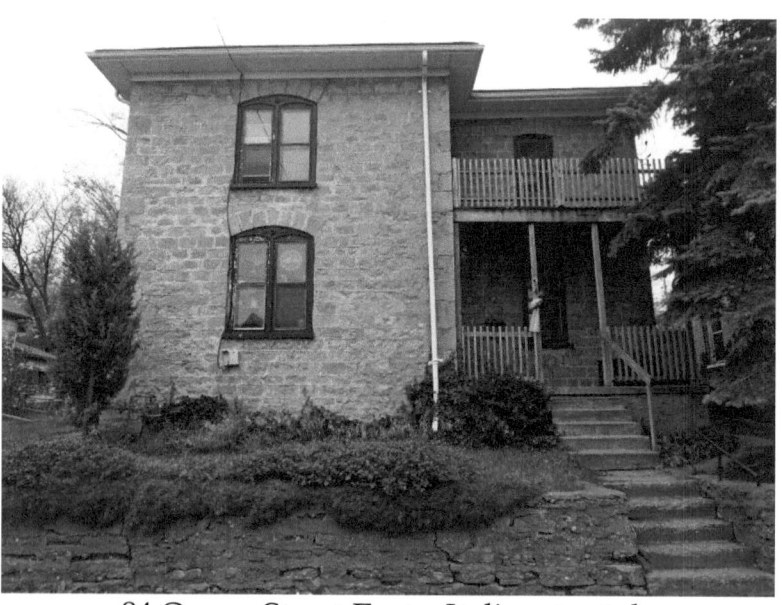

94 Queen Street East – Italianate style

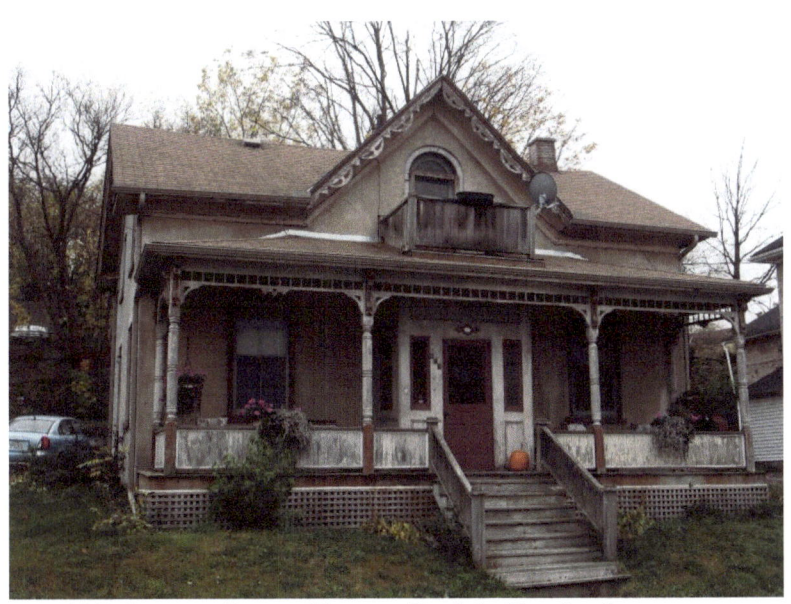

100 Queen Street East – Gothic Revival cottage, Vergeboard trim

Queen Street East – cobblestone architecture

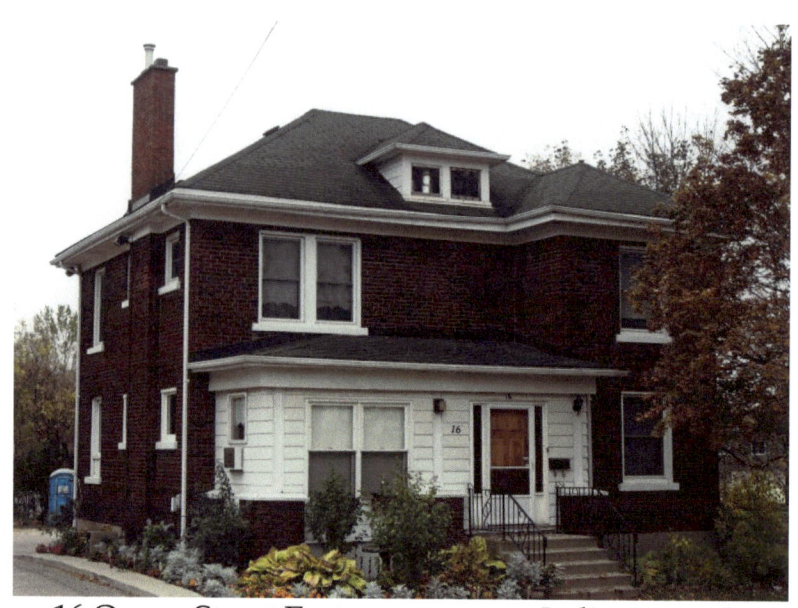

16 Queen Street East – two-storey Italianate style – dormer in attic of hipped roof

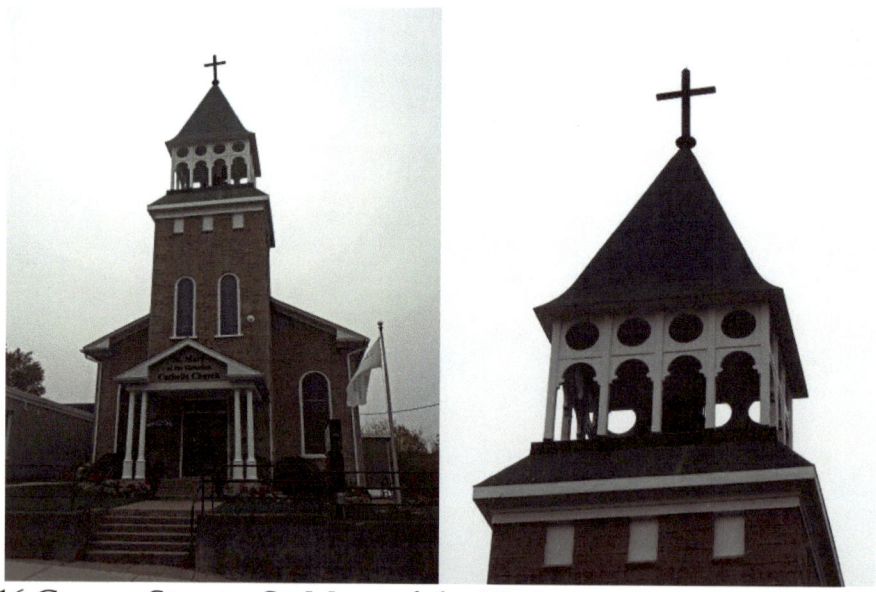

16 Cooper Street – St. Mary of the Visitation Catholic Church – cupola with bell in the tower

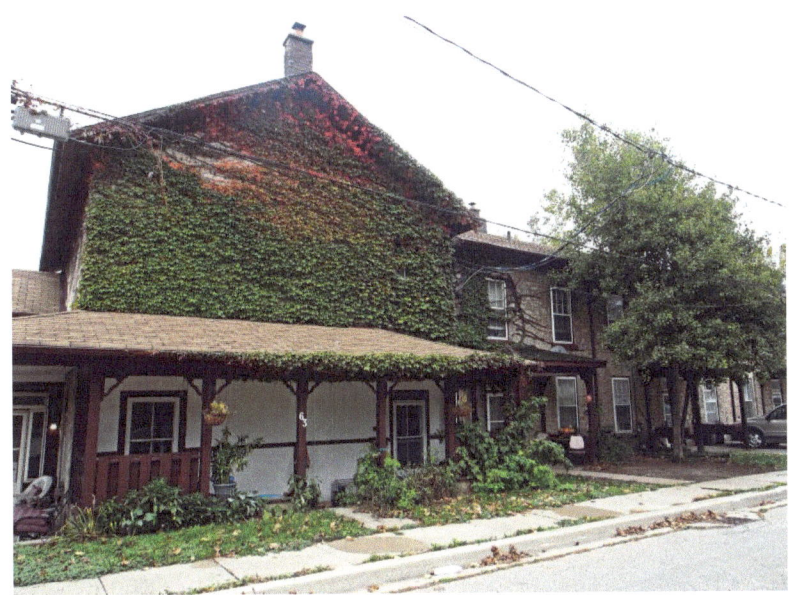

63 Spring Street – limestone construction

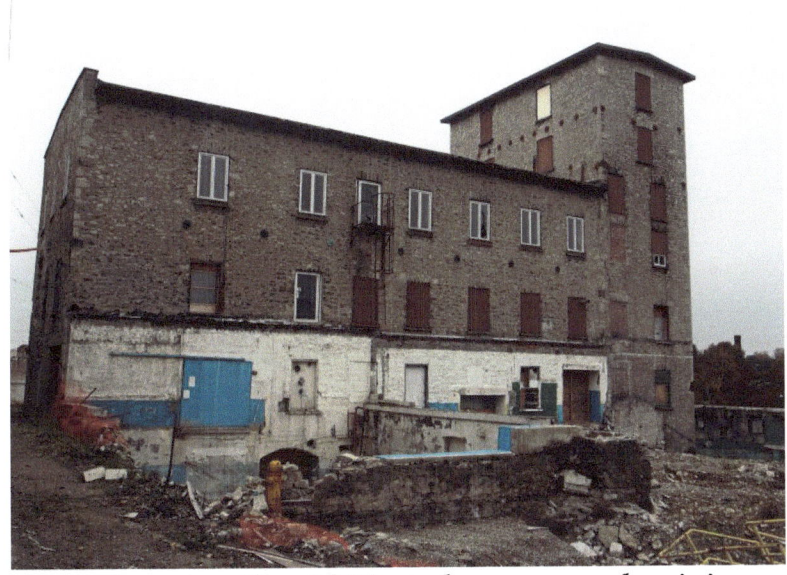

Hespeler sawmill c. 1847 – to become condominiums

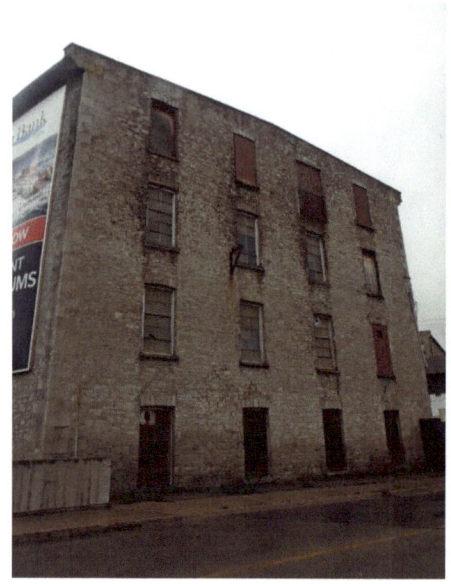
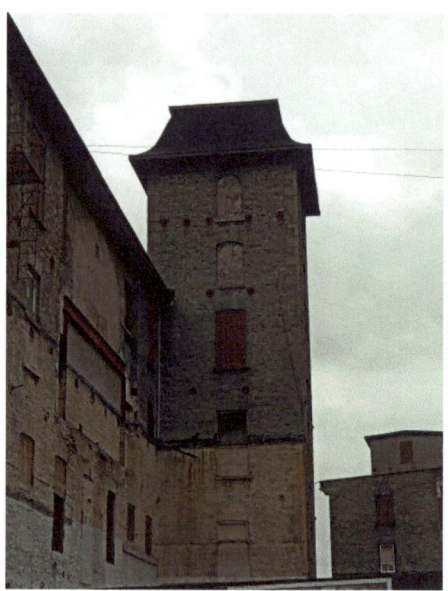
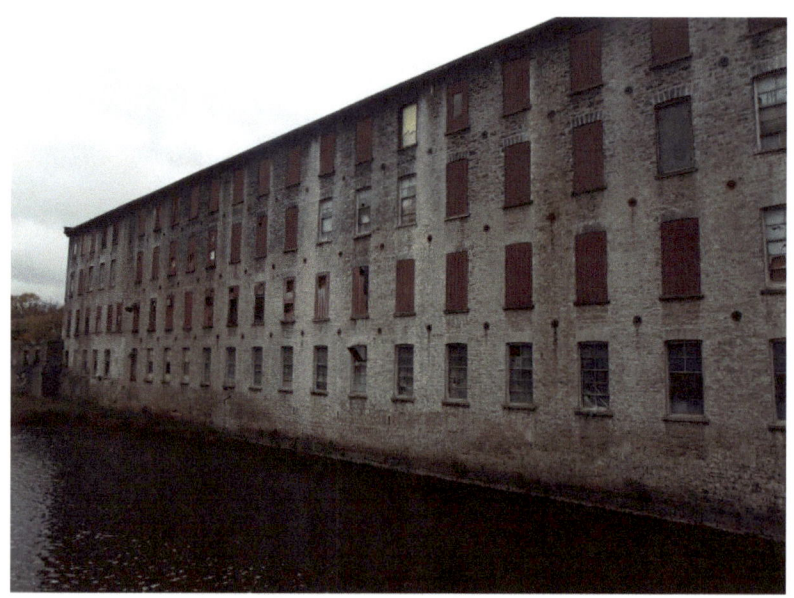

Hespeler Cotton Mill – c. 1881

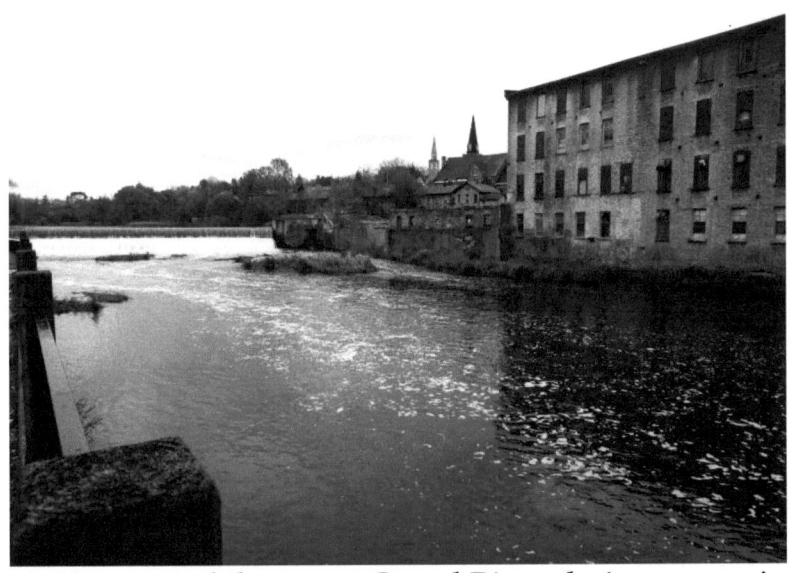

The 6,965 square kilometres Grand River drainage area is the largest drainage system in southern Ontario. The river has a vertical fall of 352 metres and extends over 290 kilometres from its source in Dundalk to its mouth at Port Maitland on Lake Erie.

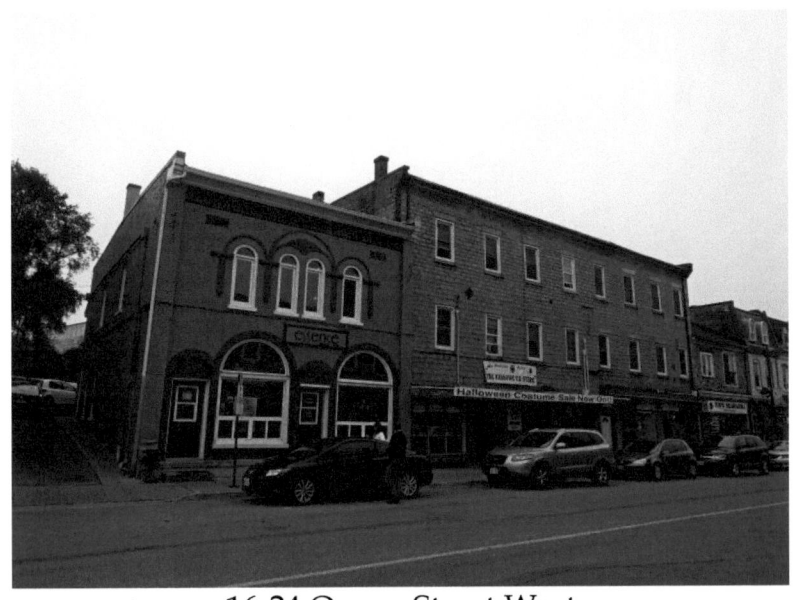

16-24 Queen Street West

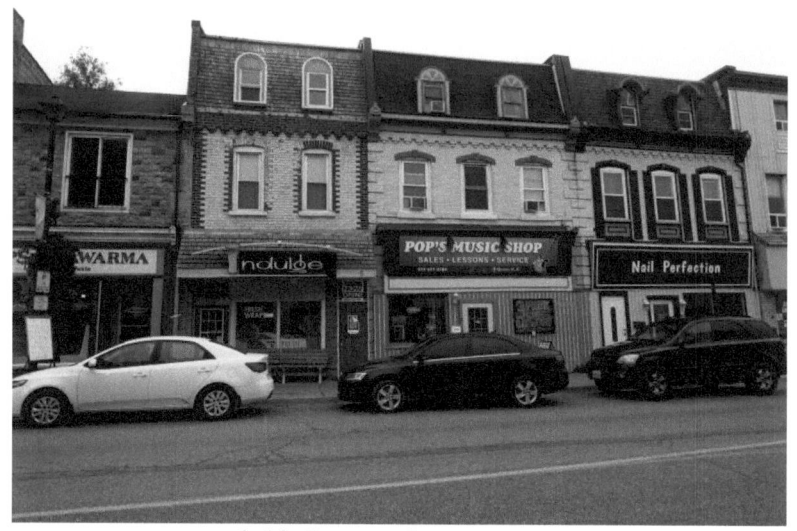
6-10 Queen Street West

15 Queen Street West

17-19 Queen Street West

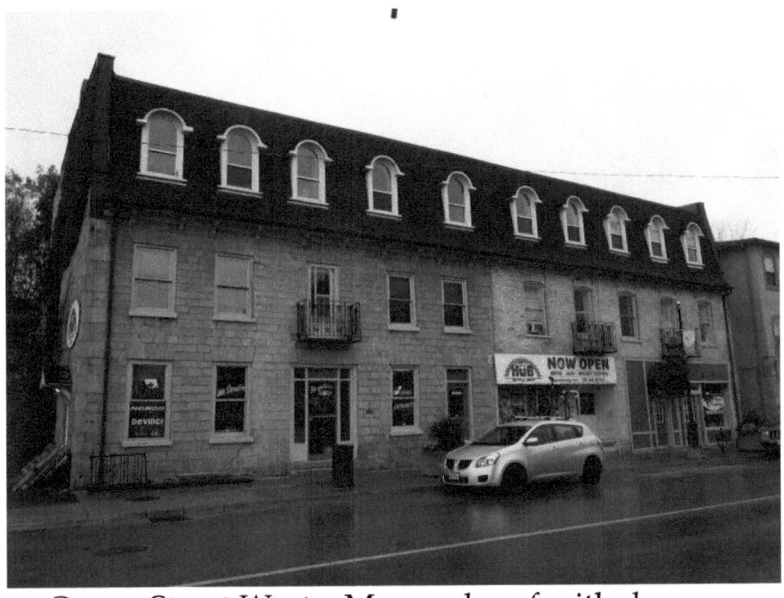

Queen Street West – Mansard roof with dormers

7 Queen Street West

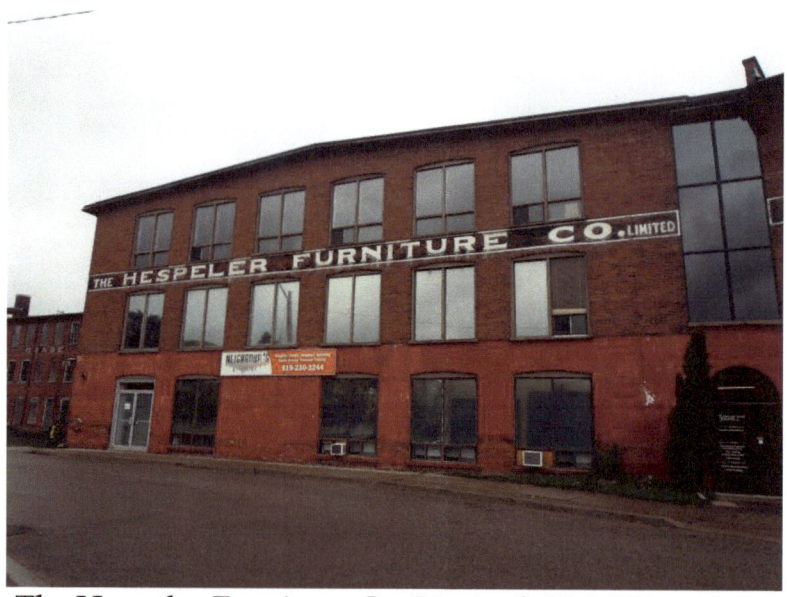

The Hespeler Furniture Co. Limited, 25 Milling Road
– Manufacturers of bedroom, and dining room furniture

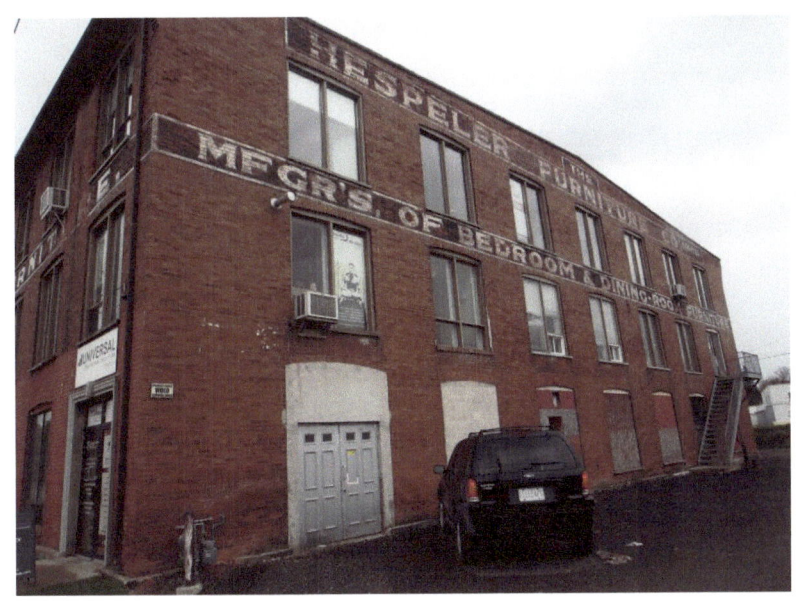

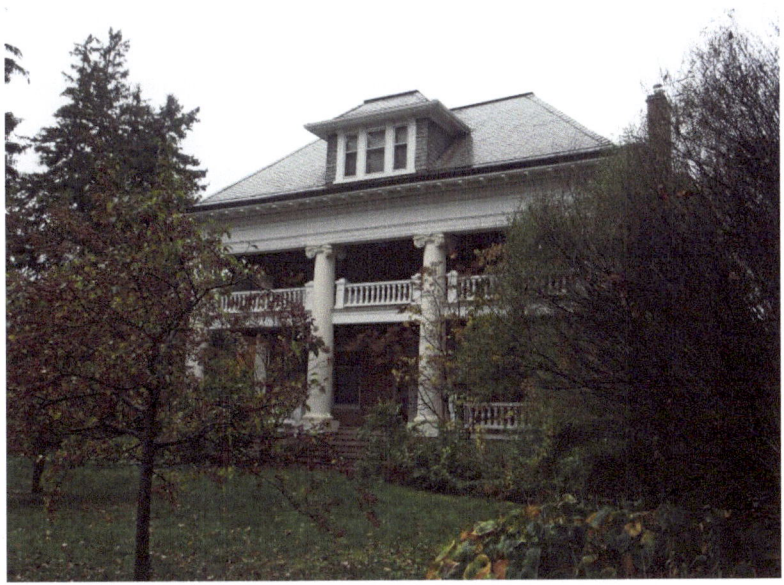

171 Guelph Avenue – Italianate style – dormer in attic of hipped roof – Forbes Estate – built for the daughter of industrialist Robert Forbes

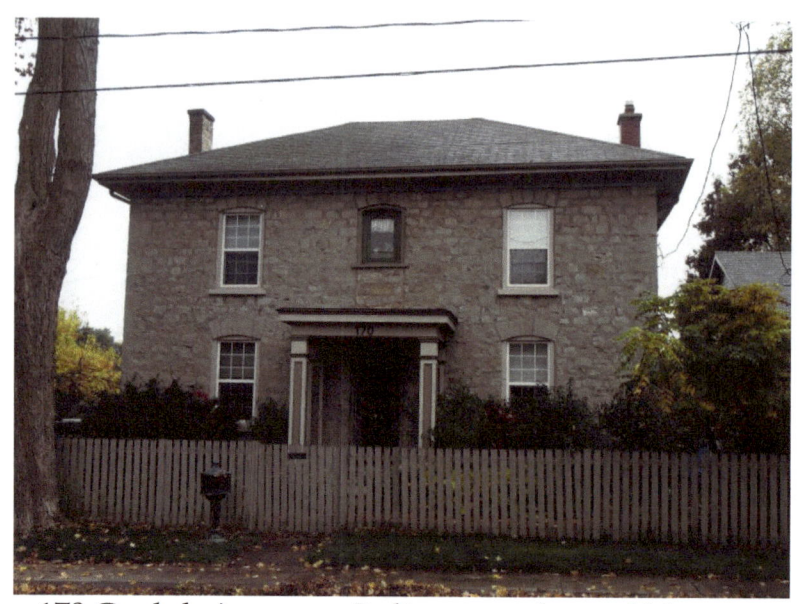

170 Guelph Avenue – Italianate style – cobblestone construction

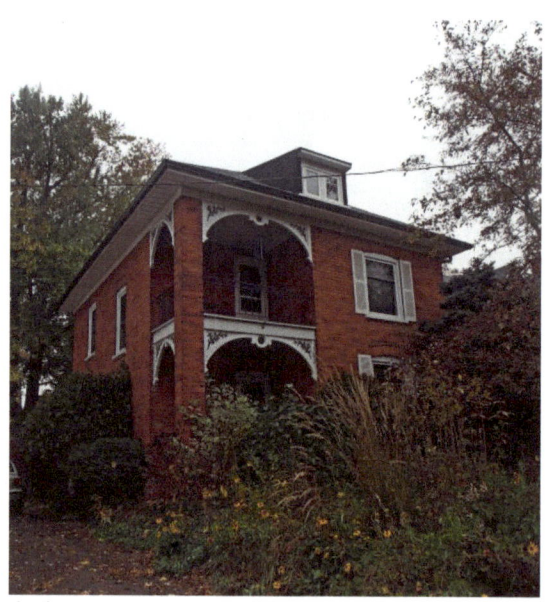

Guelph Avenue – Italianate – dormer in attic – decorative fretwork

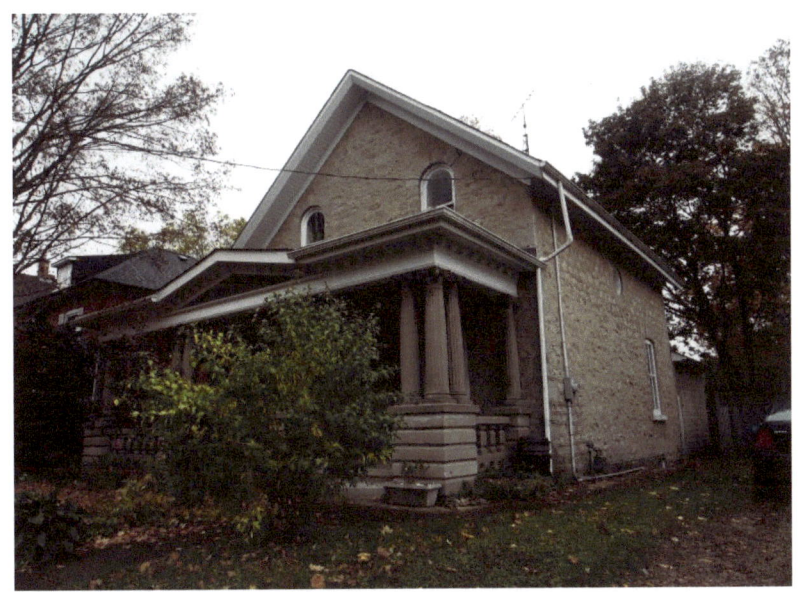

186 Guelph Avenue – Gothic Revival, verandah columns with decorative capitals

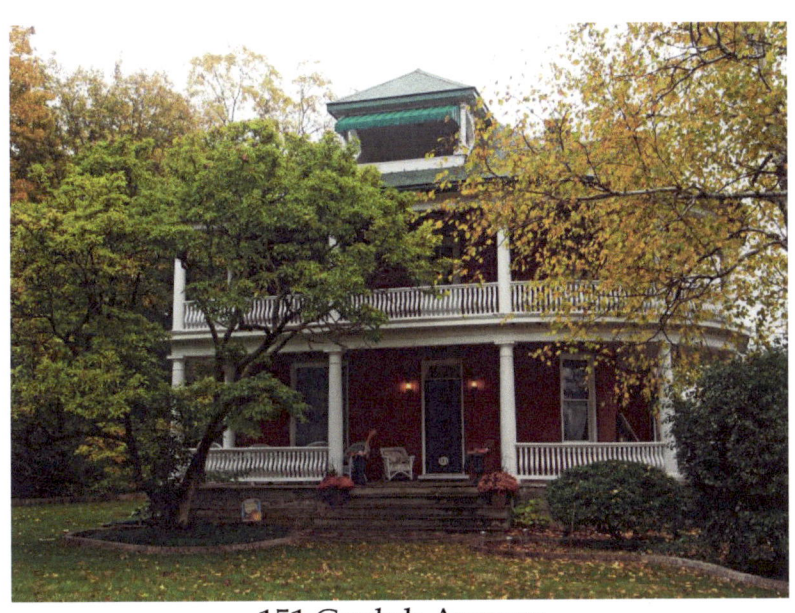

151 Guelph Avenue

Architectural Terms

Belvedere: (from the Italian "beautiful view") an architectural feature on a roof, in a garden or on a terrace that gives a beautiful view. Example: Blair Road, Preston	
Brackets: a decorative or weight-bearing structural element which forms a right angle with one side against a wall and the other under a projecting surface such as an eave or roof. Example: 14 Blair Road, Preston	
Buttress: a masonry structure built against or projecting from a wall which serves to support or reinforce the wall. In Canadian architecture, they are sometimes used for decoration. Example: 12 Blair Road	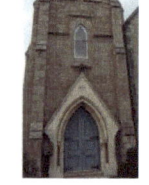
Capital: The uppermost finish or decoration on a column. Example: 70 Blair Road, Preston	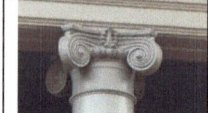
Cobblestone architecture: Refers to the use of cobblestones embedded in mortar as a method for erecting walls on houses and commercial buildings. Example: Queen Street East, Hespeler	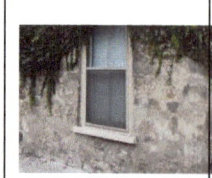

Cornice: originally the wooden overhang of the roof. With the use of stone, brick, iron and steel, the cornice is any projecting shelf at the top of a ceiling or roof. They can be very decorative. Example: 70 Blair Road, Preston	
Cornice Return: decorative element on the end of a gable. Example: 65 Blair Road, Preston	
Cupola: a small, dome-like structure on top of a building often used to provide a lookout or to admit light and air. Example: 16 Cooper Street, Hespeler	
Dentil Moulding: an even series of rectangles used as ornamental decoration in cornices. Example: 11 Tannery Street East, Hespeler	
Dichromatic brickwork: the use of two colours of brick, tile or slate to decorate a façade. Example: 94 Blair Road	
Dormer: (French for "sleep") a gable end window that pierces through the plane of a sloping roof surface to create usable space in the top floor or attic of a building by adding headroom. Example: 27 Blair Road, Preston	

Gable: the triangular portion of a wall between the edges of a sloping roof. Example: 32 Adam Street, Hespeler	
Hipped Roof: a roof where all sides slope downwards to the walls with no gables. Example: 16 Queen Street East, Hespeler	
Keystones and Voussoirs: a voussoir is a wedge-shaped element used in building an arch. A keystone is the central stone that locks all the stones into position, allowing the arch to bear weight. A keystone is often enlarged and embellished. Example of Voussoirs: 96 Blair Road	
Lancet Window: a tall, narrow window with a pointed arch at its top. Example: 18 Tannery Street East, Hespeler	
Mansard Roof: This style was popularized by Francois Mansart (1598-1666), an accomplished architect of the French Baroque period and especially fashionable during the Second French Empire (1852-1870). This roof is almost flat on the top section, with two slopes on each of its sides with the lower slope at a steeper angle than the upper and having dormer windows. Example: Queen Street West, Hespeler	

Palladian Window: a large window that is divided into three sections with the centre section larger than the two side sections and usually arched. Example: 65 Blair Road, Preston	
Pediment: a triangular section above the horizontal structure (entablature), typically supported by columns. The inside of the triangle is called the tympanum. Example: 14 Blair Road, Preston	
Quoin: masonry blocks at the corner of a wall, often a decorative feature, usually larger or of a different colour than the rest of the wall. Example: 14 Blair Road	
Rose Window: a circular window with ornamental tracery radiating from the centre. Example: 12 Blair Road, Preston – Trinity Anglican Church	
Vergeboards: also called bargeboards – hang from the projecting end of a roof and are often elaborately carved and ornamented. Example: 86 Blair Road, Blair Village	

Hespeler's Building Styles

Beaux Arts: Promoters of this style sought to express the classical principles on a grand and imposing scale. Many of the Beaux Arts buildings were banks, post offices, and railway stations. The Ontario Beaux Arts style is eclectic mixing elements of Classical, Renaissance and Baroque. Often the designs have a temple-like façade, pedimented porticos, balustrades, capitals in many styles Example: Tannery Street East – Fire Hall and old City Hall for Hespeler	
Georgian, before 1860 – This style began with the British King Georges in the 18th century. These buildings have balanced facades around a central door, medium-pitched gable roofs, and small paned windows. Example: 1679 Blair Road	
Regency Cottage, 1830-1860 – This style originated in England in 1815 and spread to Ontario later in the 19th century as British officers retired to Canada. It is a modest one-storey house with a low-pitched hip roof and has a symmetrical front façade. Example: King Street East, Preston	
Gothic Revival, 1830-1890 – These decorative buildings have sharply-pitched gables with highly detailed vergeboards, pointed-arch window openings, and dichromatic brickwork. It is a common style in Ontario. Example: 100 Queen Street East, Hespeler	

Italianate, 1850-1900 – It has wide-bracketed eaves, belvederes, wrap-around verandahs. Example: 14 Blair Road, Preston	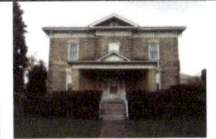
Second Empire, 1860-1880 – The mansard roof is the most noteworthy feature of this style and is evidence of the French origins. Projecting central towers and one or two-storey bays can also be present. Example: 1170 King Street, Preston	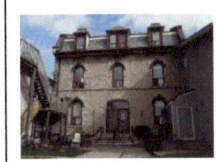
Queen Anne, 1885-1900 – This style is distinguished by an irregular outline featuring a combination of an offset tower, broad gables, projecting two-storey bays, verandahs, multi-sloped roofs, and tall, decorative chimneys. A mixture of brick and wood is common. Windows often have one large single-paned bottom sash and small panes in the upper sash. Example: 126 Blair Road	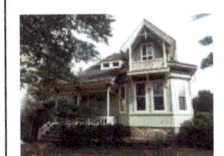
Edwardian, 1900-1930 – This style bridges the ornate and elaborate styles of the Victorian era and the simplified styles of the 20th century. Balanced facades, simple roof lines, dormer windows, large front porches, and smooth brick surfaces are its characteristics. Example: 1705 Blair Road	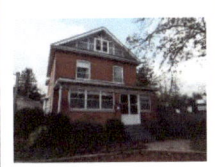

www.ingramcontent.com/pod-product-compliance
Lightning Source LLC
Chambersburg PA
CBHW040858180526
45159CB00001B/458